IMAGES
of America

SOUTHBURY REVISITED

IMAGES
of America

SOUTHBURY REVISITED

Virginia Palmer-Skok

ARCADIA

Published by Arcadia Publishing
Charleston SC, Chicago IL, Portsmouth NH, San Francisco CA

Printed in Great Britain

Library of Congress Catalog Card Number: 2005928936

For all general information contact Arcadia Publishing at:
Telephone 843-853-2070
Fax 843-853-0044
E-mail sales@arcadiapublishing.com
For customer service and orders:
Toll-Free 1-888-313-2665

Visit us on the Internet at http://www.arcadiapublishing.com

CONTENTS

ACKNOWLEDGMENTS

I would like to thank those individuals and organizations that have donated photographs to be used in this book. This publication would not have been possible without the generosity and foresight of those benefactors. Special thanks go to the Southbury Historical Society.

I would also like to thank my dear mother, Catherine Palmer, and my husband, Andrew Skok, for dedicating many hours and insights that have greatly contributed to this piece and made it possible.

The contributors are Kathryn Renee Blum, R. Allen Brinley, Debra Cooper Camejo, Helen Matula Cooper, Bill and Kayanne Davis, John and Lynn Dwyer, Olive Hine Ewald, Nancy and Darton Greist, Delores Klesitz Hatfield, Richard Hine, Elsie Stessel Horvath, Tom Lautenschlager, Doris Lewis, Grace Lewis, Ann Hinman Lilley, Judy Lovdal, Cecily Mauer, the McAllister family, Dorothy Manville, Paul and Catherine Palmer, Wilma Phillips, Virginia Platt, Southbury Historical Society, Vladimir and Svetlana Tchistiakov, Esther Terrill Townsend, Sanford and June Tschauder, Jane Ewald White, Robert L. Williams, and Walter and Patricia Winship.

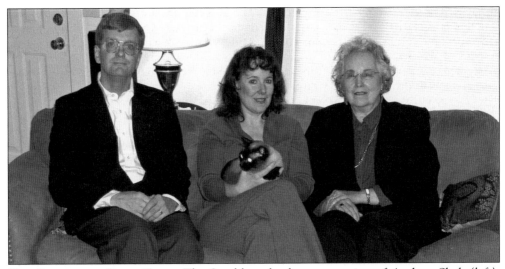

THE SOUTHBURY BOOK TEAM. The Southbury book team consists of Andrew Skok (left), Virginia Palmer-Skok (center), and Catherine Palmer.

INTRODUCTION

Southbury Revisited is a continuation of the "stepping into the past" that began with *Southbury*. Southbury's history has evolved through its residents and the paths they followed through time in their stewardship of this once forested wilderness. The peaceful and industrious Pootatuck Indians were here in Southbury's early days as hunters, fishermen, farmers, and creators of a culture of note. A wealth of natural resources provided a stable environment in which there was a food supply, materials for shelter, and opportunity to develop a social order. A governing council with leadership by a chieftain and tribal rules assured the functioning of the community. Trade was conducted with tribes outside the area, and trade routes were established. Footpaths along waterways later became cart and wagon paths as other settlers moved in the area.

The next settlers recorded in Southbury's past were 15 families who petitioned their church society in Stratford to come to Pomperaug Plantation, as this area was named. They wished to leave their church because of religious dissatisfaction with church practices, as well as the need to acquire more farming land for their growing families. Granted permission, they arrived in the area now known as Settler's Park in 1673 and rested under a spreading white oak tree. Another group arrived a few days later. The Hinman, Stiles, and Curtiss families were granted land in the area of town that became known as the White Oak section. Other families settled in parts of Woodbury. From 1678 to 1759, the Pootatucks sold their property to the settlers. With the last transaction, they left the area and settled in Kent. Their early settlement became memorialized in the 20th century, with designation on the National Register of Archaeological Sites. Connecticut Light and Power Company has owned this site since 1917.

The Congregational Church Society in Ancient Woodbury was formed and endured. During the next 100 years, the settlement's six parishes sought meetinghouses closer to their homes, particularly necessary during the winter months when travel was difficult. Petitions for separate townships were also successful, and Southbury became a town apart from Ancient Woodbury in 1787. Southbury encompasses an area of 40.9 square miles.

Manufacturing of a variety of goods began to flourish near streams and rivers. Waterpower generated the energy to power machinery to produce products sold locally and to other communities. Over 60 small mills and factories were in operation in the 1800s. The use of coal and oil as longer-lasting energy sources added to the development of manufacturing. Cars replaced horse-and-wagon travel. Farming employed the use of machinery to plant and harvest crops. District schoolchildren came together in one large consolidated school when cars and buses took the place of walking to school. The construction of dams to create hydroelectric plants in harnessing waterpower for generating electricity brought enormous progress to

Southbury. The dams also created the formation of Lake Zoar in 1919 and Lake Lillinonah in 1955. The appeal of these beautiful man-made lakes drew summer vacationers for the enjoyment of boating, swimming, and camping. Many visitors became year-round residents.

Interstate 84 was built in 1963. This highway opened the community for both travelers and new residents. Larger cities became more easily accessible for commuting, and the lure of country living appealed to former city dwellers. A unique retirement community of 2,500 condominiums, called Heritage Village, was built in the late 1960s. This attracted citizens of age 55 and older to settle here.

As fewer working farms remained in Southbury, land was sold to developers for residential growth. The population grew by leaps and bounds. Back in the 1970s, the population was between 5,000 and 6,000 residents. Route 67 was a two-lane road through Southbury, with few traffic lights. K-Mart Plaza was the former location of a large home with business offices on the first floor and a shop on the second floor. A laundromat operated in the rear of the area for the convenience of residents. Green's General Store was located where a furniture store is currently located next to the Talbot's store. On Sunday mornings after church, a shopper could buy the Sunday newspaper, groceries, and if needed, a pair of boots or other necessary sundries in this then busy store.

The Pootatuck Indians and the Ancient Woodbury's first settlers started on this path that progressed from footpath to cart to wagon trail and to the present bustling Main Street, over which some 20,000 inhabitants and a steady stream of commuters from neighboring communities drive on a regular basis. Southbury's historical heritage spans the past three centuries and reflects the resourcefulness of both the earliest Americans and current residents in preserving the town's attributes of the past for future generations.

One

SOUTHBURY PROPER

Settlers came to Southbury only half a century after the Pilgrims settled Plymouth Colony. They came due to religious dissent in their Stratford Ecclesiastical Society. Many descendants of those early 15 families live in the area today.

Yesterday's Town lay shy and green
With Purple Haunts passing unseen
But hidden in Its Simple Sphere
Were Emerald Dreams that quickened there—

I once knew Meadows—rank with Spring—
Where Rivulets beguiling spell
Trickled to Babbling Brooks that sped
With music Nature could not still—

How coveted were the Valleys Deep—
The Velvet Spread of Woodlands Wild—
This ecstasy of innocence
Unraveled for the mind of child—

Such innocence—in truth—has fled
Its Finer Beauty come and gone
Now man made facts have settled in
Upon the Space of Earth's Own Song

But over the miles I've traveled since
Through cities—heartlands—up and down—
All other planes I've walked upon
Prove pale in the Mist—of Yesterday's Town

—Nancy Benedict Greist
Longtime Southbury resident

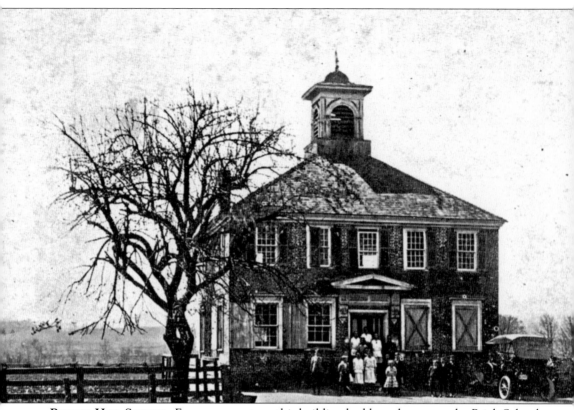

BULLET HILL SCHOOL. For over a century, this building had been known as the Brick School. The clay for its bricks came from nearby Bullet Hill. It is one of the oldest school buildings in continuous use. Its origin dates back to 1762. The Brick School became known as Bullet Hill School after the Revolutionary War. Members of the military were required to conduct regular arms practice. The Southbury Militia shot into the hill behind the area now known as Southbury Plaza. After each practice, the lead was dug from the hill and taken to the Brick School to be melted and remolded into ammunition for future gun practices. Both the practice hill and school became known as Bullet Hill. Designed in the Georgian style, the school served as a district school from the 1700s until the end of 1941. The Friends of Bullet Hill School saved it from ruin in the 1960s and 1970s. Today, the cupola still holds the original bell, from 1835, and the school is listed on the National Register of Historic Places.

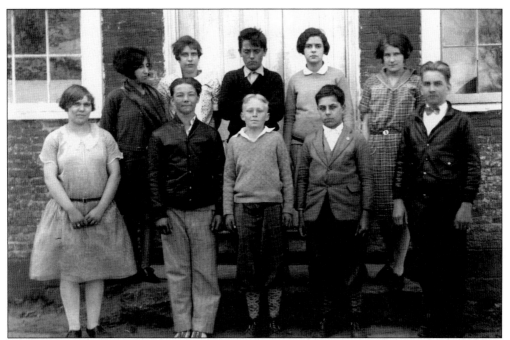

BULLET HILL SCHOOL, CLASS OF 1928. From left to right are (first row) Ruth Smith, Frank Matula, Sigard Lovdal, John Gaudzmas, and Harry Hull; (second row) Hazel Dupel, Evelyn MacBath, Jim Hine, Marion King, and Irene Hoyt. The Bullet Hill School was utilized until the Consolidated School opened in 1942.

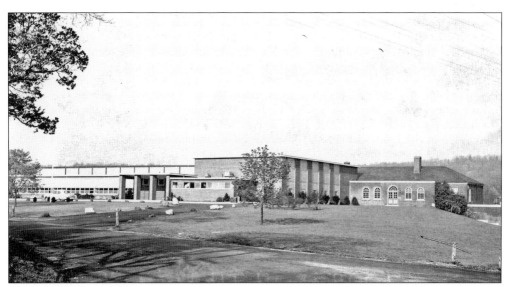

CONSOLIDATED SCHOOL. When the school opened in January 1942, there were 206 students in attendance from the six Southbury District schools. High school students attended the Woodbury High School. Due to a limited state financial allocation, there were only seven classrooms, although there were eight groups of students. One teacher was assigned to teach two classes. As the town population grew, another wing was added. The school was renamed Rochambeau School and then Gainfield Elementary School.

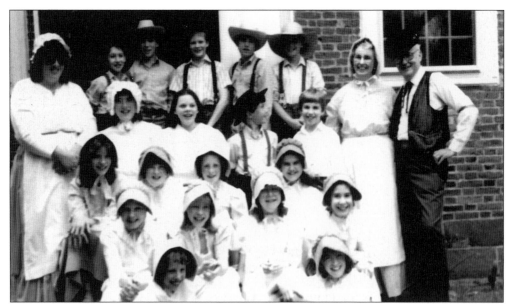

LIVING MUSEUM PROGRAM, 1988. Gainfield Elementary students reenact a typical 1800s school day at Bullet Hill School. From left to right are (first row) Allison Brinley and Lauren Garille; (second row) Danielle Riley, Megan Larsen, Mia LaFrance, and Amy Williams; (third row) Noreen Nilan, Becky Matula, John Noonan, Kevin Kastelein, teacher and program founder Catherine Palmer, and selectman Paul Palmer; (fourth row) docent Sue Matula, Matthew Divine, John Thibodeau, Matthew Voity, Sean Doherty, and Todd Ritchie.

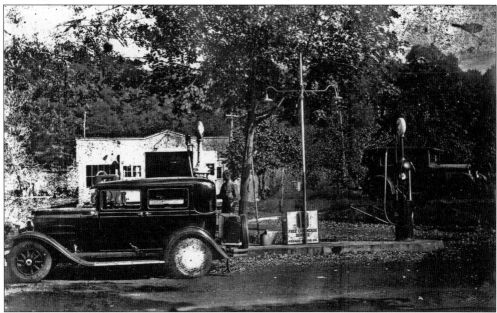

DOWNTOWN GAS STATION. With the invention of the automobile in the early 1900s, gasoline was purchased at general stores by the bucketful. In 1905, the first gas pump was invented, and curbside filling stations were developed with shedlike structures for their attendants. By 1910, gas stations with larger offices were being built, and later, Shell and Standard Oil began painting their logos on their buildings as brand names were developed.

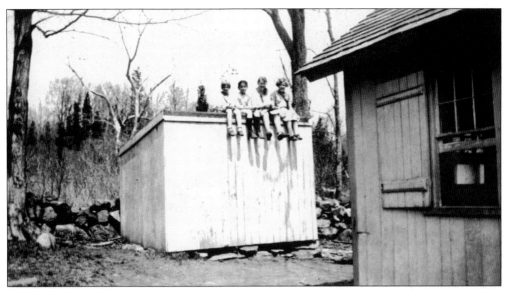

STUDENTS SITTING ATOP THE PRIVY AT KETTLETOWN SCHOOL. In the early 1900s, schools had no running water, and there were outside outhouses, convenience houses, or privies. The word privy is derived from "private house."

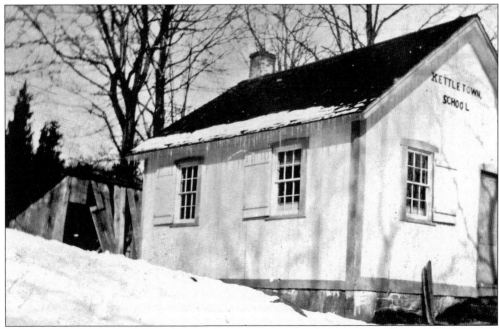

KETTLETOWN SCHOOLHOUSE. School districts were named for each Ecclesiastical Society. In 1789, Kettletown was School District No. 4. The Kettletown School on North George's Hill Road was built in 1860 and closed in 1929. In the early 1900s, Fanny Vogelbach (Lewis) came from Essex to teach in Southbury. The school is now a private residence.

OLD HUNDRED WAITRESSES IN TRADITIONAL UNIFORM. The restaurant was opened around 1933 by Nellie Brown in her family's summer home. It no longer stands. It was located on Main Street North adjacent to where the Old Field Condos are today. A goat named Billy Blue was the restaurant trademark in the Brown family summer home. Waitresses served the famous Hunt Table suppers on Thursday nights. Each table had a silver coffee service much like a hostess used at home. Breakfast, lunch, tea, and dinner were served from March to the end of November. Old-fashioned chicken pie, "like Mother used to make," was served.

LEWIS HINE AND PHOEBE OSBORNE HINE, C. 1850. Lewis Hine (1782–1865) married Phoebe Osborne of Southbury in 1810. The Hines had three children.

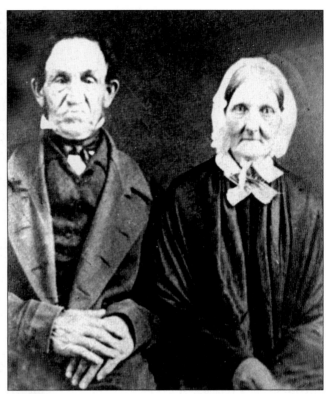

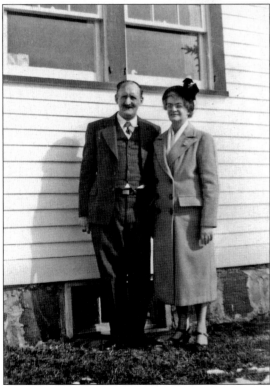

MYRON AND FANNY LEWIS, C. 1951. Ten generations of the Lewises have been born in America since the family's arrival in the early years. Family businesses in town included sawmills, charcoal pits, and ice cutting. Aaron Lewis's son, Isaac, had a sawmill in the location where the Southbury Plaza now stands. It was dismantled in 1970, and parts were sent to Sturbridge Village.

VIEW LOOKING NORTH, C. 1906. Until the 1920s, roads were not kept free of snow in the winter. Between 1918 and about 1926, the roads were difficult to maintain for both horse-drawn travel and automobiles. Any surface suitable for one was not adequate for the other. Paved roads could be damaged by horseshoes, and unpaved roads were detrimental to automobiles, particularly in the rainy season.

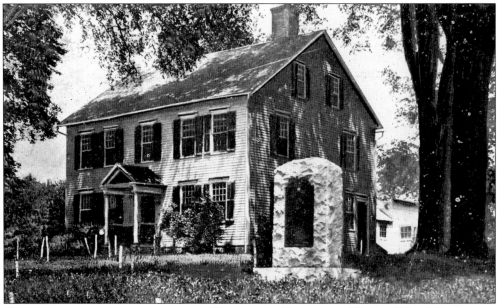

CONGREGATIONAL PARSONAGE NEAR WATERBURY ROAD AND WORLD WAR MONUMENT, C. 1925. This property stands on four acres of land and was built in 1766 by Peter Barnum, a distant relative of famous circus promoter P. T. Barnum. The first clergyman to inhabit the house was Rev. Benjamin Wildman in 1812. The monument was moved and is now located between the new town hall and the library.

KETTLETOWN SCHOOLCHILDREN,
c. 1923. Fannie Vogelback (Lewis) is
the schoolmarm. From left to right are
(first row) James Wilson, Olga Sinkewicz,
Esther London, and Johnny Gillotti;
(second row) Cecil Lewis and Rosali
Gillotti; (third row) Ernest Overstate,
Reginald Lewis, Frankie Pierce, and Charles
Sinkewicz; (fourth row) Kenny Lewis,
Mildred Lewis, and Nicholas Gillotti.

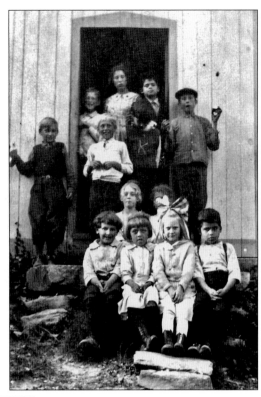

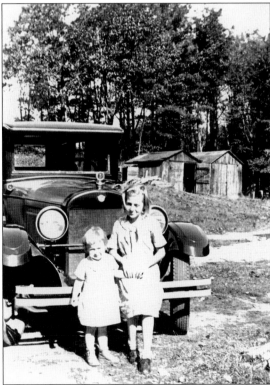

NANCY BENEDICT (GREIST) AND JEAN
BENEDICT (LOVDAL) BY THE FAMILY
CAR ON ROUTE 6, MAIN STREET,
c. 1935. In 1930, the Connecticut
State Grange called a meeting of all
people interested in the improvement
of rural roads. Produce delivered in
the state was many times delayed,
and quality suffered in the winter
months. The Connecticut Rural Roads
Improvement Association was formed.

HINMAN FAMILY, C. 1890. The Hinmans summered here. Pictured at the family home on Main Street North are, from left to right, Edward Hinman, Belle (Edward's wife), Jennie Hinman (standing), Marnie Hinman, William (Marnie's husband), and Matthew Hinman.

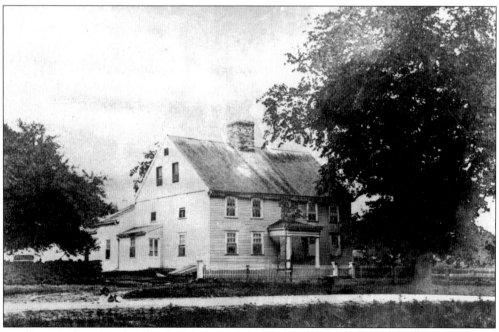

HINMAN FAMILY HOMESTEAD, MAIN STREET NORTH. Col. Benjamin Hinman built the homestead in 1743. He passed the house to his son Aaron and then to his grandson Judge William Hinman. His son William moved to Brooklyn to operate a profitable store and only opened the house in the summer. Col. William Hinman moved here in 1930.

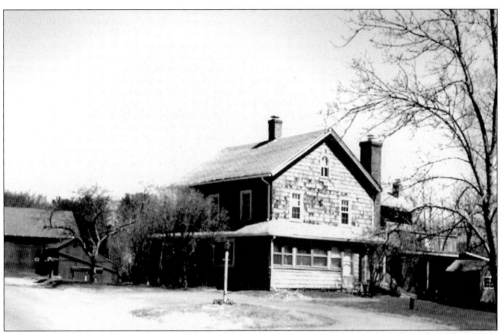

MATULA FAMILY FARM, LOW BRIDGE ROAD. The farm was also known as the Old Field Farm. This house was shown on the 1868 Beers map as the W. Warner Home. When it was purchased in the 1940s, it had beautiful balsam trees nearby. The family owned the homestead for over 50 years. The land was sold and is in the area now known as Settlers Park.

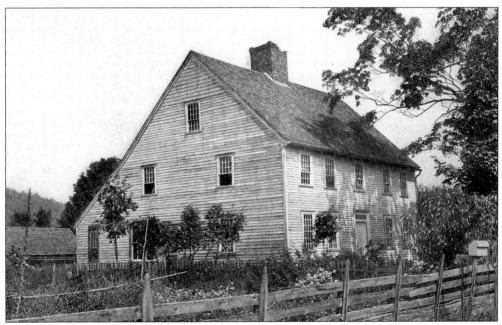

HOUSE NEAR SANDY HOOK, SOUTHBURY ROAD. This house is typical of 18th-century houses of the lean-to variety. The windows are divided into 24 sections.

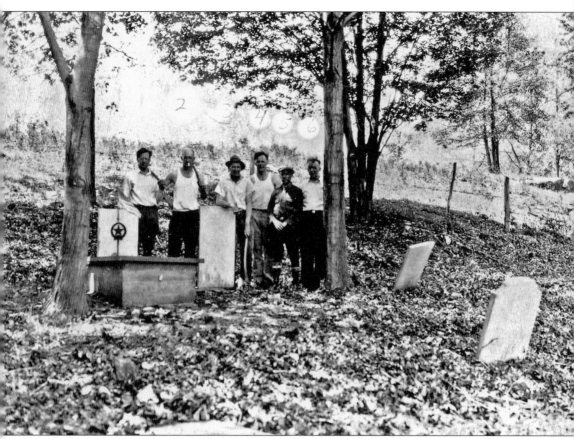

REVOLUTIONARY WAR SOLDIER'S GRAVE IN ABANDONED CEMETERY, NORTH GEORGE'S HILL ROAD. Pictured is the 1933 Revolutionary War Veterans Clean-Up Committee of the Veterans of Foreign Wars. From left to right are Eli Hicock, Harold A. Benedict, Harold Hennessy, Milton Coer, Antonio Candido, and Martin Stowe. The war created a big change in New England, as agricultural products were needed for the army. Unfortunately, this initiated a depression in area farming after the war, when there was no longer a need to supply the military with farming supplies.

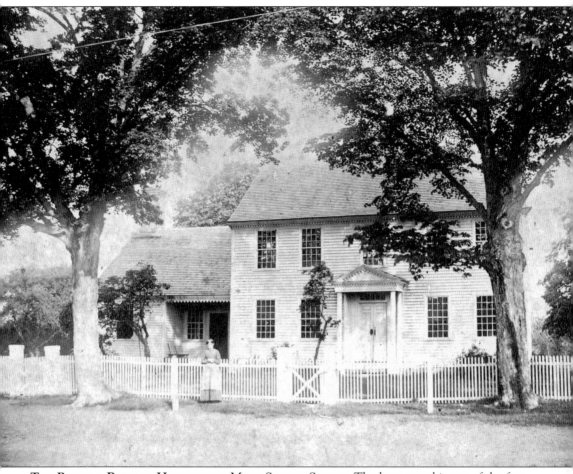

THE RUSSELL-BRINLEY HOMESTEAD, MAIN STREET SOUTH. The homestead is one of the few remaining historic buildings along this stretch of road. The original house, to the south end of the present building, included a long room, back kitchen, and borning room. There were nine doors out of the main room. In 1799, a well-known Revolutionary War soldier named Amos Johnson was responsible for its creation. Lore states that when news of the surrender of Cornwallis reached Woodbury, people assembled together at the meetinghouse and the bells pealed to signify joyfulness. The three Johnson brothers, Amos, Justus, and Moses, lived three quarters of a mile away in Southbury just across the Pomperaug River. They thought the bells were ringing to muster troops, since bells were typically rung to call the faithful to services. All the brothers appeared at the alarm post armed and equipped and ready for service. Amos Johnson was later elected as a town selectman. His family lived in the house into the 1860s, when it became the property of the Russell and Brinley families, who owned it until the late 1900s. The home was reconstructed in 1940, and it is now the Southbury Funeral Home.

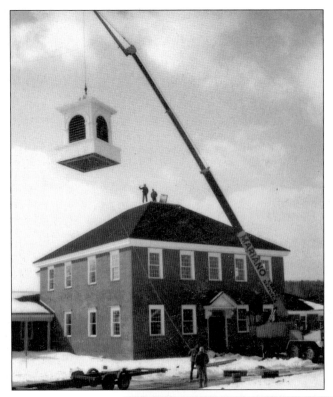

CRANE WITH TOWN HALL CUPOLA. The steeple came from the South Britain Congregational Church and was more than 140 years old. It was given to the town by Catherine McCarthy, a town employee who worked in the first Southbury Town Hall in the South Britain section of town, the second town hall, and the third town hall. When she stepped down, she held the record of being the town's oldest employee at the time of retirement.

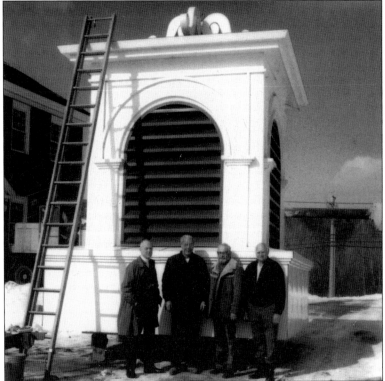

TOWN OFFICIALS NEAR CUPOLA, 1976. Local dignitaries stand in front of the cupola before it is lifted by crane and placed on top of the town's third town hall.

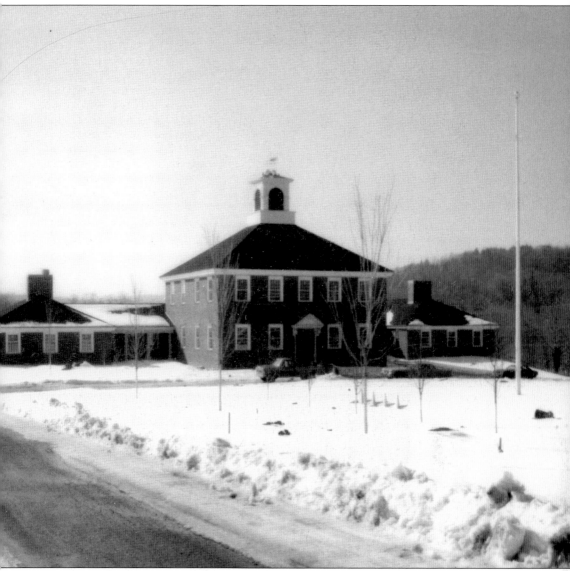

SOUTHBURY'S THIRD TOWN HALL, BUILT IN 1976. The town of Southbury has had three town halls in its history. The first, built in South Britain in 1873, is now the Town Hall Museum, which is maintained by the Southbury Historical Buildings Commission. The second, now known as the Town Hall Annex, was built in 1963 on Peter Road. In the third town hall, former resident David Merrill painted murals of historic locations on the walls along the staircase. Also prominently displayed are a Southbury Historical Society plaque listing names of citizens honored for outstanding community service. National Arbor Day Foundation's Tree City USA Awards for seven years are displayed also. An International Arboricultural Award and Connecticut Urban Forestry Award are on view.

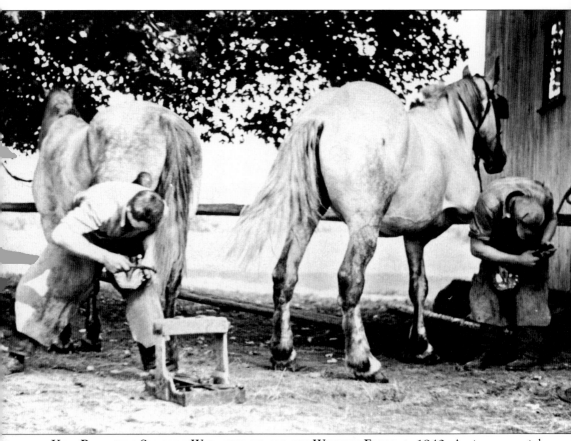

Kriz Brothers Shoeing Workhorses on the Winship Farm, c. 1940. An important job of blacksmiths was the proper shoeing of horses. Each crack required individual analysis with regard to the corrective treatment and shoeing. The general principle is to have the farrier or blacksmith use a toe clip on each side of the crack across it to prevent wall expansion and to lower the wall below the crack so it will not bear weight causing spreading of the crack. Gum was used to seal the crack along with corrective staples that could be used to prevent expansion and contraction of the crack during movement of the horse.

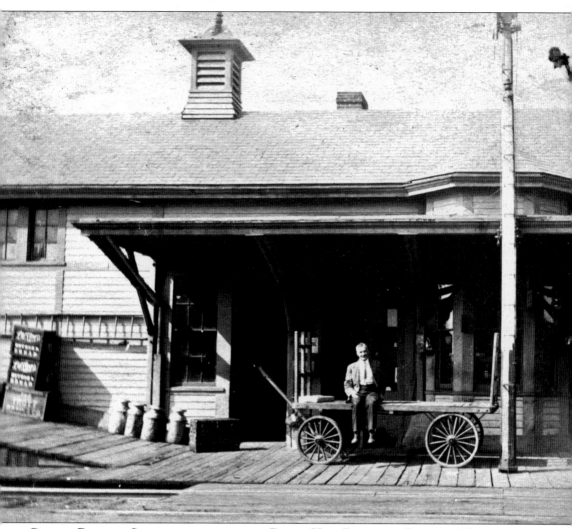

GEORGE BREWER, STATIONMASTER OF THE DEPOT HILL RAILROAD STATION. The station was located between Interstate 84 and Route 6 near the oil storage tanks of St. Pierre. After passenger service was discontinued, grain and hay were brought in from Danbury until the mid-1940s. The station was sold to Western Union Telegraph and then to H. H. Stone, who used it for storage. In the winter of 1966, the building was destroyed by fire.

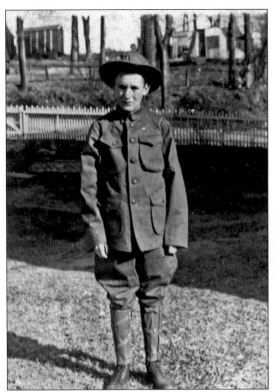

SOLDIER MYRON LEWIS OF WORLD WAR I, C. 1918. Myron Lewis and 64 fellow soldiers are memorialized on the World War I monument engraved, "In honor of those from Southbury who served in World War 1917–1919."

LEWIS HOMESTEAD, NORTH GEORGES AND KETTLETOWN ROADS, C. 1920. In 1920, there were 260 families in town, with a population of 1,093.

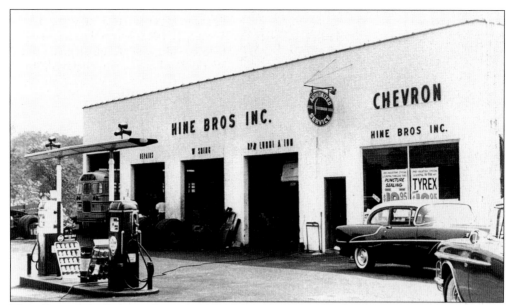

HINE BROTHERS SERVICE STATION, C. 1957. This garage is almost 60 years old. It has been remodeled and enlarged with a brick exterior and is located at 67 Main Street South. James and Richard Hine were joined by their brother Howard in operating this business in 1947. The building has been altered several times. An addition was added to the back of the building, and then the showroom was converted into a parts room. In the late 1980s, a second floor of offices was built, and the brick face was added to the exterior of the building.

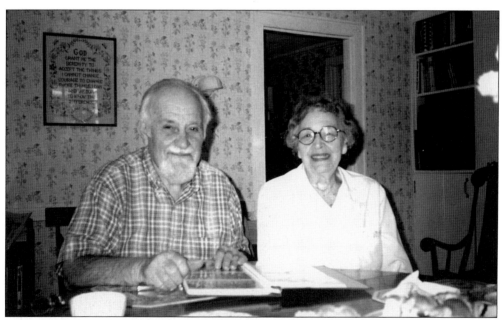

BELOVED SOUTHBURY TEACHERS CARMAN CATER AND VIVIAN TARBOX, 1998. Vivian Tarbox attended a one-room schoolhouse and also taught in other district schools in Southbury and South Britain. She and Carman Cater both taught at Southbury Consolidated School, which was later called Rochambeau School during their tenure. It is now the Gainfield Elementary School.

27

FAMILY CAR IN SOUTHBURY, EARLY 1900S. Automobiles became more common in the early 1900s, which led to a greater demand for better bridges and roads. Before long, automobiles took the place of mules and horses. Steam cars had been built in the United States even before the Civil War, but the early ones were like miniature locomotives. Dr. J. W. Carhart, in 1871, built a working steam car.

GERTRUDE HAND (HINE), BULLET HILL SCHOOL TEACHER, EARLY 1900S. This picture of Gertrude Hine was taken prior to her marriage. When she was about 16 and was teaching at Bullet Hill School, she met her future husband, Elliott Wheeler Hine, who was her student and also age 16. She attended Danbury Normal School to earn her teacher's certificate and then went on to teach young teachers. Her two daughters, a granddaughter, and a great-granddaughter all became teachers, following in her footsteps.

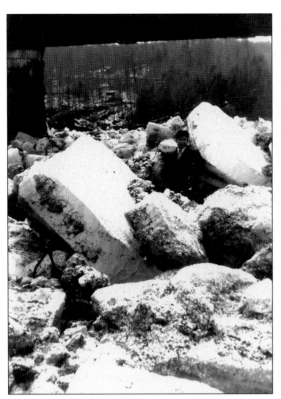

JAMES HORVATH BY STEEL BRIDGE, WINTER 1935. James Horvath was photographed by his future wife as he stood on the huge blocks of ice in the unusual ice jam on the river.

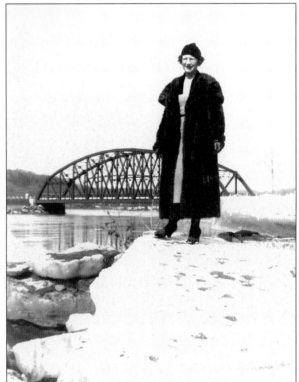

ELSIE STESSEL NEAR RIVER ROAD. The future wife of James Horvath is dressed in her Sunday best, right down to her high heels, as was the custom when couples were courting in the early- to mid-1900s.

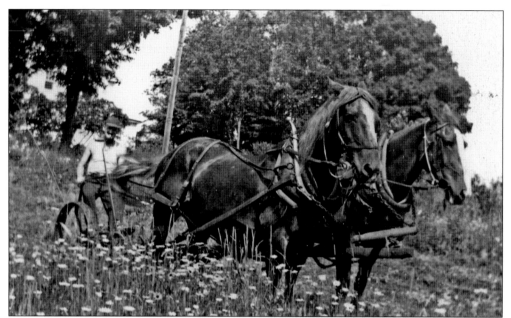

LEWIS BOY WITH TEAM OF HORSES, EARLY 1900S. The farming practices of the early Colonials were exploitive, and by the early 1800s, much of the land was worn out. A great wave of improvement came about with the agricultural press and some experimental farmers. In the 1860s, grant colleges were started, and in the early 1900s, the extension system was started. The extension services linked researchers from colleges with farmers.

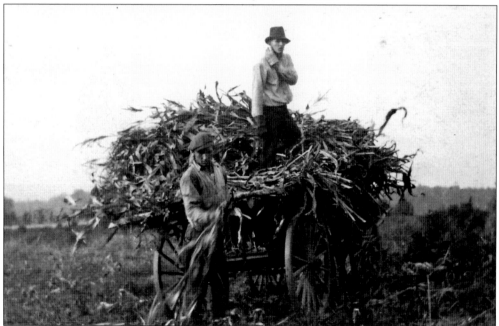

GETTING THE CORN AT KETTLETOWN LEWIS FARM. In 1948, there were 151 agricultural workers in town. Corn was the primary grain of New England. During the mid-1800s, sweet corn replaced Indian corn in popularity. Corn was also used for fodder for livestock, and farmers would let animals out into the fields after harvest to root out and eat the remaining stalks.

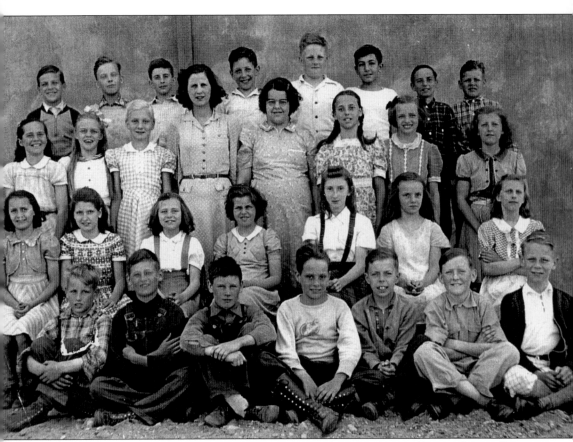

SOUTHBURY CONSOLIDATED SCHOOL, 1942. From left to right are (first row) Russell Brown, Norman Cole, Harold Cole, Charles Harris, Ernest Larsen, Edwin Grisgraber, and Ernest Earnhardt; (second row) Dolores Klesitz, Shirley Makl, Katie Coe, Margie Keech, Evelyn Barnes, Althea Hicock, and Patty Hicock; (third row) Kathleen Ingram, Ellen Hicock, Alice Johnson, teacher Edna Dumschott, Lorraine Parsell, Helen Hatfield, Betty Jane Lewis, and Arlene Grisgraber; (fourth row) unidentified, Jack Hoyt, Joe Jameson, Garwood Platt, Walter Harrison, Alfie Candido, Charles Ingram, and Dick Manville.

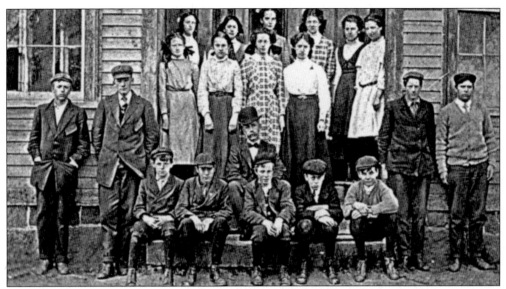

SOUTHBURY SELECT SCHOOL AT FIRST TOWN HALL, C. 1911. From left to right are (first row) Howard Worden, Henry Cassidy, Jack Fleming, Lloyd Fowler, and Roger Williams; (second row) teacher Reverend Taylor; (third row) Evangeline Cassidy, Frances Utal, Joesphine Pierce, and Dorothy Platt; (fourth row) Ruth Hubbell, Helen Taylor, Evelyn Williams, Majorie Pierce, Mary Fuller, and ? Cassidy.

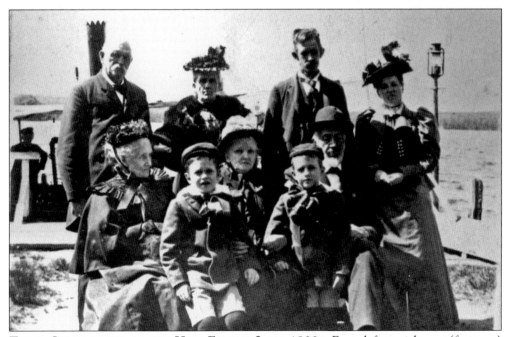

THREE GENERATIONS OF THE HINE FAMILY, LATE 1800s. From left to right are (first row) Elliott Wheeler Hine and George Franklin Hine; (second row) Sarah Hine, Angeline Hine, and Elliott Hine; (third row) two unidentified friends, Charles Elliott Hine, and Anna Estella Wheeler Hine.

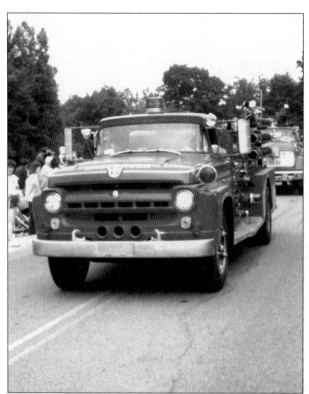

SOUTHBURY FIRE TRUCK. The fire truck was bought for $21,000 in 1957. When the truck was 23 years old, the Southbury Volunteer Fire Department replaced it and then donated it to the town of Eastbrook, Maine, which is near the Canadian border.

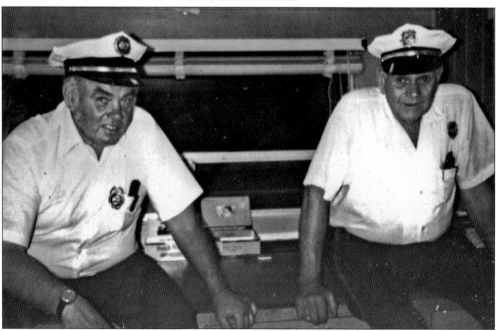

LEADERS OF SOUTHBURY FIRE DEPARTMENT, C. 1950. Fire chief George Stone (left) served until 1966. Fire chief Kenneth Baldwin (right) also served the community as a selectman and as president of the Lions Club in the 1940s. Arza Bennett was the first chief of the volunteer fire department, which was organized in 1932.

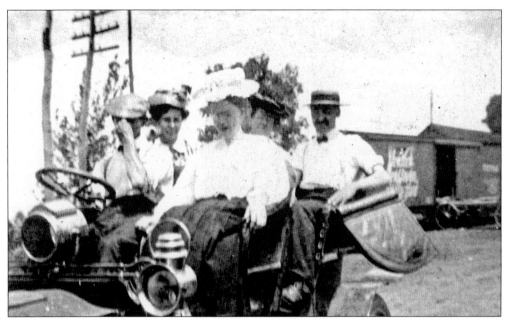

LADIES ARRIVING AT THE TRAIN STATION. Built in the 1850s, the station was one of the stops on the New Haven Railroad, which ran from Poughkeepsie, New York, to Waterbury. The trains were all steam powered, and the sparks from passing trains caused many small fires. After passenger service ended in the mid-1940s, grain and hay continued to come in from Danbury on the freight train.

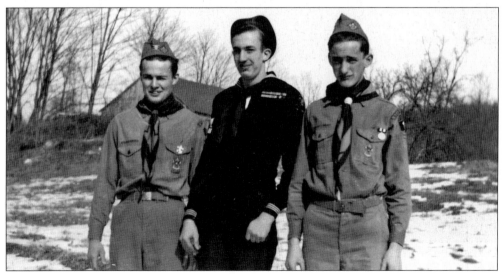

MEN IN UNIFORM. The Lewis brothers—Reg, Elmer, and Bob—pose in military uniform and Boy Scout apparel in 1946.

OLD BACK CEMETERY. This sacred place is also known as Old Middle Ground. Other old cemeteries in town include Pierce Hollow, South Britain, George's Hill, Pine Hill, White Oak, Sacred Heart, Warner, French Family Vault, South Britain, and Lone Grave Farm. The oldest cemetery is the Pootatuck Indian burying ground near River Road.

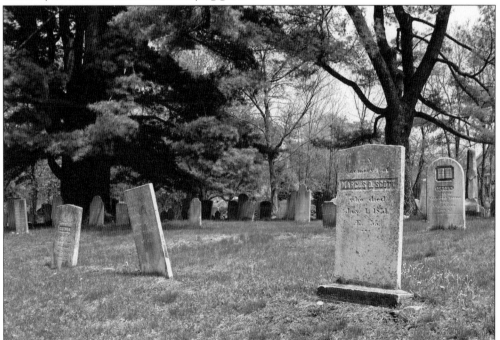

MIDDLE GROUND CEMETERY. Gravestones from Connecticut were made primarily from three types of stone: red, granite, and slate. Occasionally, regionalized stones were used, as evidenced in cemeteries in the Killingworth part of the state.

SUSAN JACKSON'S DAUGHTER. Susan Jackson was an important citizen in the community in the late 19th and early 20th centuries. She was born into slavery around 1850 and came to the area as a domestic around 1875. In 1784, the Connecticut legislature abolished slavery and determined that any African American born after March 1, 1784, could not be held in servitude after reaching 25 years of age.

WHEELER HOUSE. The house is located on the west bank of the Pomperaug River. A member of the Wheeler family built it around 1740. In the early days, it was considered an important site, for there was a mill nearby run by waterpower. It was owned by an important Revolutionary War figure, Captain Curtiss, at one time. In recent times, it was owned by famed entertainer Victor Borge. Now, it is the Heritage Village Meeting House.

SIGNING IN AT BULLET HILL SCHOOL REUNION, 1968. Virginia Hicock Harris signs in at Alumni Day at Bullet Hill School while old friends share special memories on this special day.

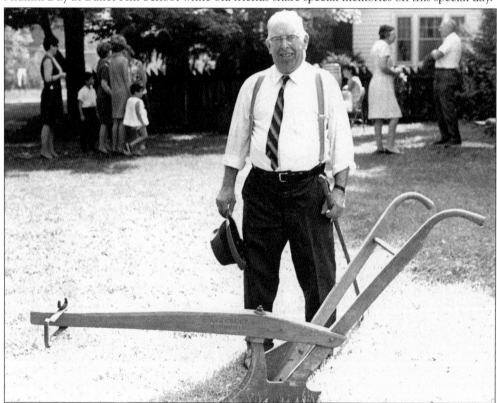

OUTSIDE BULLET HILL SCHOOL WITH PLOW, 1968. Lloyd Fowler holds what is thought to be a Wakelee plow that was manufactured in early Southbury in the Community House section of Southbury. The Coer family donated the plow. Fowler was part of the Friends of Bullet Hill School and an officer in the Southbury Historical Society, which evolved from the Friends organization.

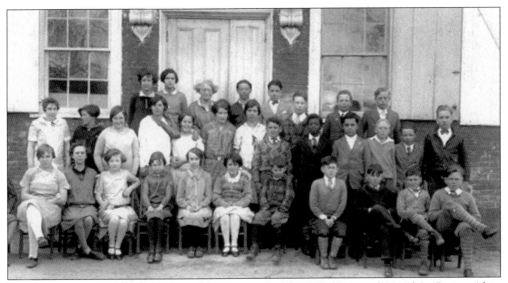

BULLET HILL SCHOOL CLASS OF 1929. From left to right are (first row) Hazel St. Pierre, Alice Coates, Flora Roger, Virginia Wells, Dorothy Hatstat, Edith Dennis, Ruth Hine, Arthur Dennis, Harry Dennis, Hubert Reynolds, Ernest Hicock, and Harvey Stone; (second row) Evelyn McBath, Olive Hine, Edna Olson, Eleanor Ingram, Gertrude Brinley, Irene Hoyt, Elinor Wheeler, Melvin Wheeler, John Perry, John Gudzunas, Sigurd Lovdal, Lester Norton, and Harry Hull; (third row) Irene King, Marion King, teacher Lucy Munson, Frank Matula, Wayne Tarbox, Adam Wittek, Frederick Garbuskas, and Clarence Olson.

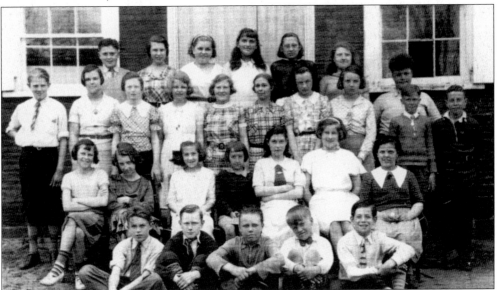

BULLET HILL SCHOOL GRADUATION, 1935–1936. From left to right are (first row) Dick Metcalf, Douglas Weasa, David Hicock, Peirce Hicock, and Louis Richmond; (second row) Mary Ingram, Helen Dennis, Bertha Grisgraber, Regina Dennis, Mary Treat, Elma Coer, and Bertha Pitcher; (third row) Paul Mackel, Majorie Hicock, Thelma Lovdal, Beatrice Whitney, Eleanor Munson, Blanche Klosnick, Mae Daniels, Thalia Hicock, Benny Chocette, and Jack Metcalf; (fourth row) Howard Hine, Margaret Pitcher, Vera Norton, Ellen Koseff, Anna Kosneski, Agnes Mackel, and George Stone.

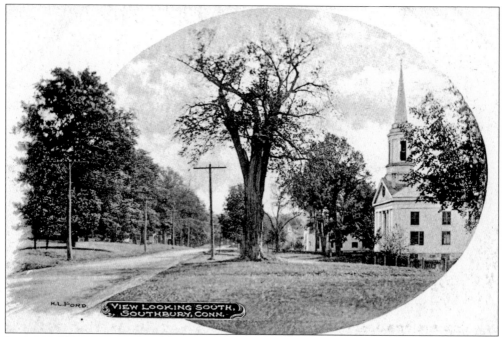

LOOKING DOWNTOWN. Southbury's profile has changed forever from the rural scene. The population continues to grow each year. Southbury is a magnet for families wishing to find a country setting with excellent schools, well-maintained roads, and a variety of shopping and medical resources.

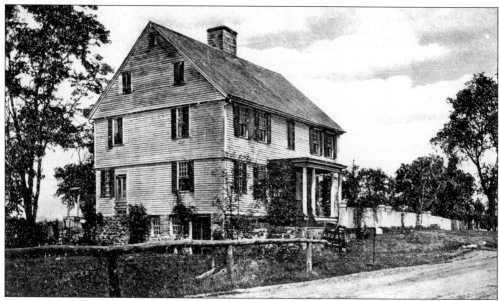

BENJAMIN HINMAN HOUSE. The house was built in 1743, or earlier, by Col. Benjamin Hinman. It consisted of the main two-story section with gable roof and stone central chimneys. Later, the house was owned by son Judge William Hinman and then by grandson William Hinman Jr. Descendants Matthew, Edward, and Jenny Hinman sold the home in 1922. It was sold again in the late 1900s.

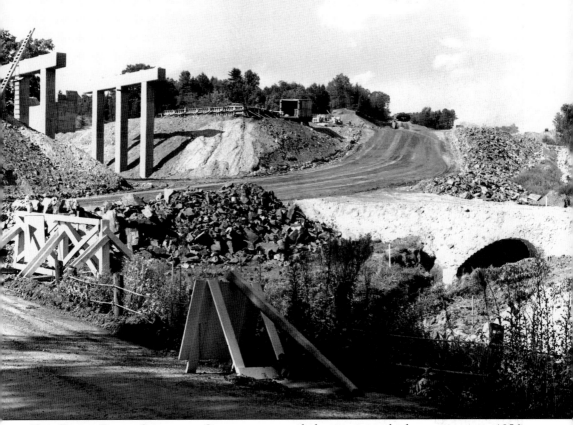

THE PETER ROAD OVERPASS. Congress approved the interstate highway system in 1956. The Peter Road overpass was under construction while Interstate 84 was being built in 1962. Interstate 84 was built over the railroad right-of-way through town from the Housatonic River via a route just south of an 18th-century road to Waterbury. Some 30 acres of land were taken from the Russell-Brinley farm by right of eminent domain by the State of Connecticut to build this section of highway. Interstate 84 transformed this rural community. With Southbury linked to the nation's bustling highway system, New England and New York became more accessible, and a new influx of travelers, businesses, and citizens changed this quiet town forever.

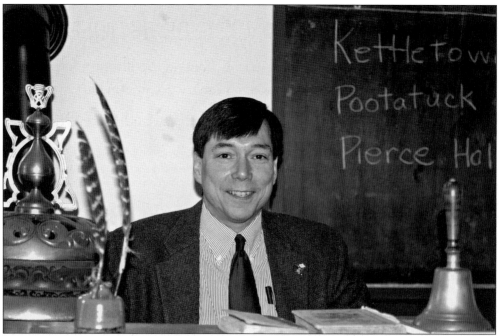

MARK COOPER, SOUTHBURY FIRST SELECTMAN, AT TEACHER'S DESK, BULLET HILL SCHOOLHOUSE. Mark Cooper is a Southbury native and attended local schools. His mother, Helen Cooper, attended Bullet Hill School, but he attended Southbury Consolidated School, as Bullet Hill was closed in 1941. Cooper has held the post of first selectman since 2001.

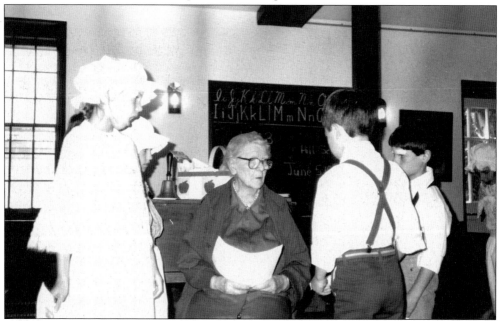

A VISIT FROM CATHERINE MCCARTHY. In an interview, Catherine McCarthy said that she was the first female principal in the state of Connecticut. She shared her early teaching experiences with Barbara Kane's visiting Gainfield Elementary School second-grade class at Bullet Hill School. The students reenacted a typical 1850s school day.

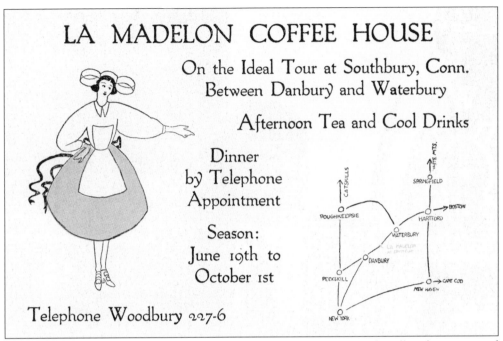

LA MADELON COFFEE HOUSE ADVERTISEMENT. This sophisticated coffee shop accepted dinner reservations.

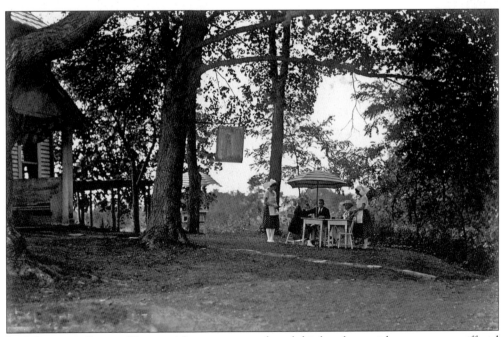

LA MADELON COFFEE HOUSE. Afternoon tea and cool drinks, along with supper, were offered between June and October.

LOOKING DOWN FROM THE RAILROAD TRACKS, C. 1960. This view is from the area along the back side of the Brinley property to the barns at 775 Main Street South. The lane of the original George's Hill Road can be seen. Southbury has grown substantially since the 1960s. The town's appearance has been altered by Interstate 84 from a rural pastoral community to a very active suburban center. The country roads of earlier years have been transposed to active roadways. George's Hill Road has been widened to accommodate the residential settlements in that area, as have roadways in other locations throughout town. In the 1970s, many roads were still not paved in town, and addresses were rural routes. Today, the only dirt roads in existence are those that were designated as scenic roads. The concept of scenic roads came about in the late 1990s due to a group of citizens who researched the concept and had it approved by the town selectman. The town currently has a population between 19,000 and 20,000 citizens.

Well Drilling at the Benedict Home, Old Field Road, 1939. The artesian well is still providing ample water today.

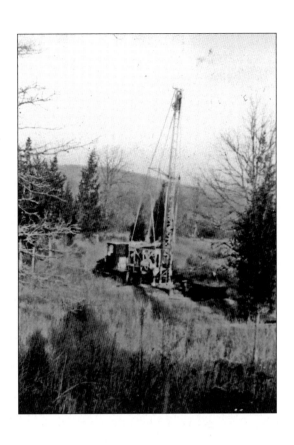

GRADUATION EXERCISES

SOUTHBURY SCHOOL

June 10, 1942
Two O'clock

Welcome - - - - - - Marion Hatstat

Flag Salute - - - Leader: LeRoy Hatfield,
 Richard Swanson
The American's Creed - Jane Platt

I Am An American - - Royal Parsell
 Richard Weber

Song - - - -"I Am An American"

The Story of the Flag - - Viola Partridge

The Writing of the Star Spangled Banner -
 Sally Brennan

Song - - - -"The Star Spangled Banner"

Remarks - - - - Mr. Frank H. Johnston

Presentation of Diplomas - Mrs. Clarence Stiles

Presentation of Mitchell Award

Song - - - - - "God Bless America"

* * *

Class Roll

Jane Beardsley	Joseph Mamerzel
Homer Bennett	Elmer Lewis
Franklyn Bradley	Floyd Manville
Viola Brennan	Deborah Minor
Elizabeth Brown	Anna Moskus
Albert Coe	Royal Parsell
Charles Cole	Viola Partridge
Lucille Grisgraber	Chester Platt
LeRoy Hatfield	Jane Platt
Marion Hatstat	Richard Swanson
Thomas Hennessey	Melvin Tomlinson
Charles Micock	Richard Weber
Jeanette Hine	Charles Willenbrock

Graduation Exercises, 1942. The program pictured highlights the June 10 event for 27 students. The program closed with the singing of "God Bless America."

45

SHELTON HOUSE. Around 1855, the Shelton family bought the "Playhouse Corner" area from the Hicocks. Around the time of the Civil War, Aaron H. Shelton built the house for his wife, Elizabeth, and son George. It is thought that the house might even be from a period earlier than the Civil War. Shelton also owned the Wakeley Plow Shop on Community House Road and had water rights on Bullet Hill Brook.

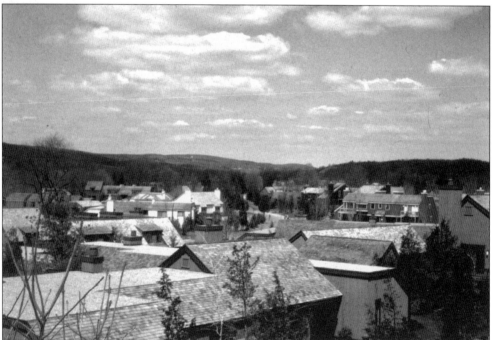

VIEW OVER HERITAGE VILLAGE. Heritage Village was built by Otto and Henry Paparazzo as an innovative and unique community approach for citizens 55 years and older. It brought many interesting people who wanted to retire in beautiful Southbury.

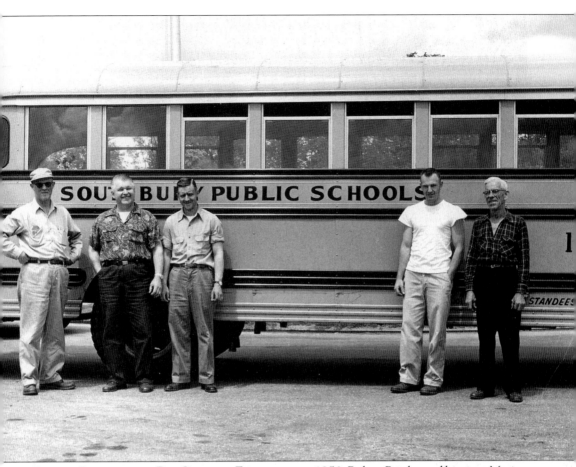

ROBERT BRINLEY WITH BUS COMPANY EMPLOYEES, C. 1950. Robert Brinley and his sister Marion Russell owned and operated the business that transported children to school within Southbury and to high schools in other towns for over 40 years. From left to right are Robert Brinley, Andy Kozinsky, Dick Swanson, Dale Hasting, and Bill Patrick. A large fire on the property threatened the barn housing the buses. Fortunately, citizens helped the Brinleys move the vehicles across the street to a safe location. Unfortunately, a larger barn on the property burned due to a lightning strike following a violent thunderstorm that passed through one night.

BAZAAR BUILDING AT HERITAGE VILLAGE. The building was recently torn down to build elegant condominiums. The building housed restaurants, Amos's Bakery and Coffee Shop, antique stores, a jewelry store, a grocery store, and specialty shops.

MRS. CARLETON LEAVENWORTH REGISTERS VISITORS AT BULLET HILL SCHOOL ALUMNI DAY, 1968. The event was held on September 12, 1968, and drew over 300 people. Mrs. Carleton Leavenworth was born in Southbury and attended the local school. She lived here for her whole life except for two years when she lived in Bridgeport. Winifred Brinley helped her to contact all of the alumni.

HAROLD BENEDICT DRIVING TRACTOR AT EDWARD HINMAN'S HOUSE, C. 1930. The Edward Hinman house is located on Main Street North. Progress came to farming when pulling and carting things went from horse-drawn vehicles to tractors, similar to this Ford tractor. By World War I, tractors were in common use. They not only served as machines to pull but were also used as mobile power sources. A turning axle that was extended out from the motor could be used to turn a water pump, thresher, and many other devices.

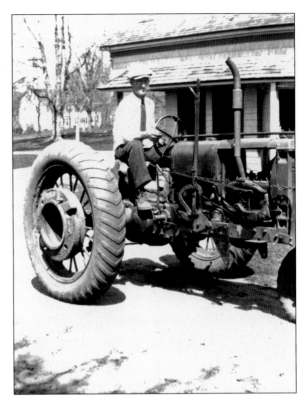

THE FLAT. This area, which was on the Winship Farm, is now used for gardening by Heritage Village residents who plant vegetables and flowers. In 1968, the family farm was sold. A total of 50 acres was sold to the Stillman brothers, and the land is now owned by the O & G Company. A small lot was sold to Melvin Wheeler. The remainder of the 400 acres was sold to the Paparazzo Brothers, who built Heritage Village.

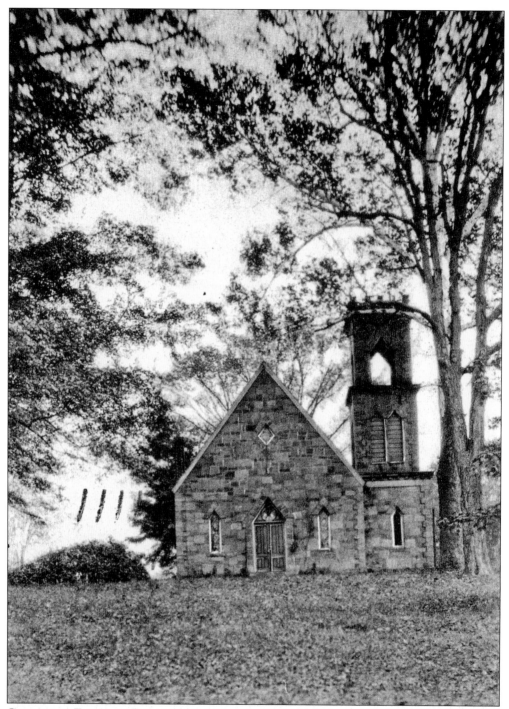

CHURCH OF EPIPHANY EPISCOPAL CHURCH. In 1843, the Episcopal Society of Southbury was organized at Bullet Hill School as the Church of the Resurrection. It became the Church of the Epiphany in 1858. The site was purchased from the Shadrach Osborne property. The cornerstone was laid in 1863, and the church was consecrated in 1867. Rev. Frederick Pratley was appointed vicar in 1972, followed by Rev. Frederick L. Curtis as rector in the late 1970s.

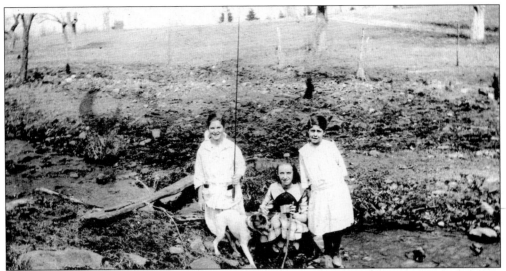

CHILDREN ENJOYING FISHING. Pictured here are Mildred Smith, Minnie Oliver, and Lucy Smith with their fishing poles. The many waterways, ponds, and lakes in town provided ample areas to fish.

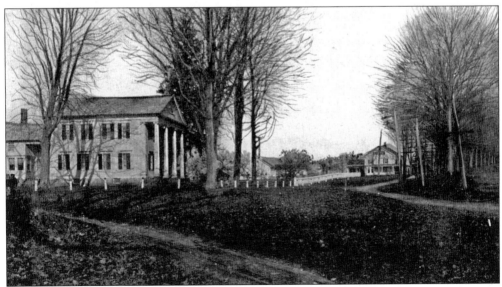

VIEW INTO SOUTHBURY. In 1795, the Woodbury Turnpike became designated as Main Street. The Woodbury town line was marked with Benjamin Franklin milestones.

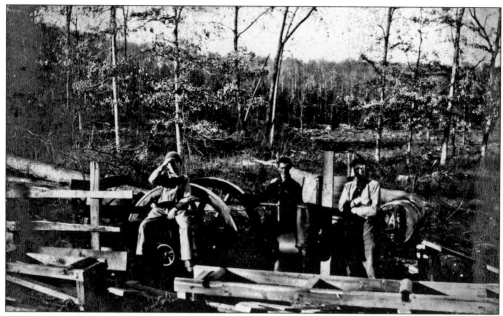

GRANDPA LEWIS'S SAWMILL, C. 1922. Between 1912 and 1916, other prominent sawmills were run by Charles Hine and Edward Scoville Sr. At various times, many mills arose to do saw jobs for timbermen. Active timbermen of that period included John Mitchell and Merwin Mitchell. The sawmills were one of the busiest places. The wood was either bought outright by the operator or was left for payment.

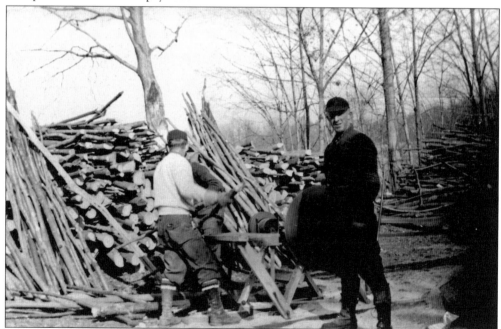

MYRON LEWIS AND CLIFF BEARDSLEY AT THE LEWIS SAWMILL, THE 1940s. This mill was off North Poverty Road near Cass Road and Cass Pond. Some of the first industries that began with the early settlers developed due to necessity: tanneries, clothiers, gristmills, and sawmills. At one time, sawmills and cider mills were seen everywhere. Distilleries were not uncommon.

KETTLETOWN SCHOOL BALL GAME, C. 1923. In 1845, Alexander Cartwright invented baseball in the United States. The rules were very different from those of today, as there were no balls or strikes called. The pitcher was told by the batter what kind of pitch to throw.

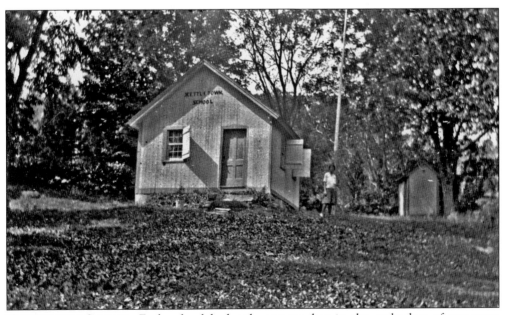

KETTLETOWN SCHOOL. Each school had only one teacher in the early days of one-room schoolhouses. Few of the schools had wells, and students usually had to get water in a pail from a neighbor's house.

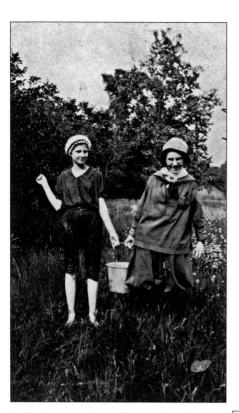

TESSIE FLEMING (STONE) AND KATHERINE STONE (LEAVENWORTH), EARLY 1900S. Katherine Stone Leavenworth was a member of the Friends of Bullet Hill School and played an important role in the Alumni Day Open House in 1968.

FANNY VOGEL. Fanny Vogel was a schoolteacher who came to Southbury from Essex to teach at a one-room schoolhouse. She married into the Lewis family. In the early days of teaching, when the schoolmarm married, she was no longer allowed to teach.

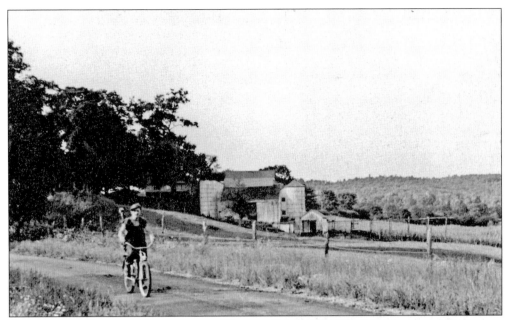

PEDALING ON POVERTY ROAD BY THE WINSHIP BARN. The Winship homestead on Poverty Road consisted of over 400 acres in the early 1800s. In the late 1800s, Anson Walter Winship was a blacksmith in South Britain. Barns were typically built after sowing and before haying because of seasonal work and the dryness of the ground. All requisite pieces had to be gathered ahead of time.

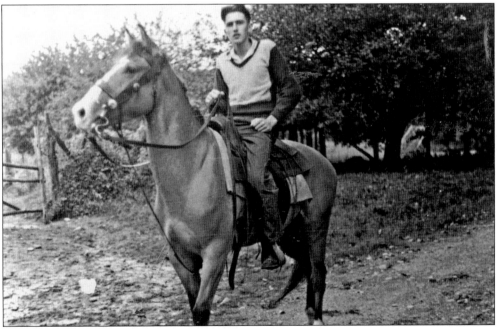

ANSON WALTER WINSHIP RIDING A HORSE ON THE FAMILY FARM, 1940. By family tradition, the first and middle names of the male Winships alternated in each succeeding generation. In addition to horses, the family raised cattle. Milk not used by the family was taken to the local creamery to be pasteurized and distributed. Anson Winship's family still resides in town.

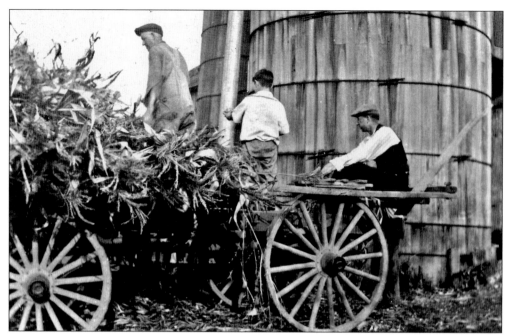

PACKING THE SILO, C. 1922. The Lewis farm is on Kettletown Road just before North George's Hill. The word silo comes from a French word meaning "pit." The original silos were trenches. Either on a surface or a trench, silage was packed in piles with no cover at all except ground limestone and sawdust. Only a few inches on top and about a foot on the sides spoiled if packed correctly.

HAYING, C. 1940. July brought the most labor-intensive period, as it was haying season. The hay had to be cut, dried, and stored for winter use. This was one time of the year where women were asked to help in the fields, although less so in New England. Other peak periods were harvest and sowing times.

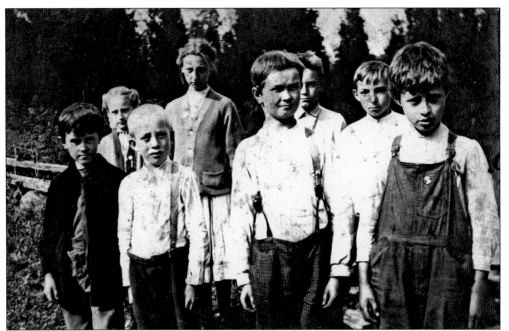

KETTLETOWN SCHOOL, 1911. From left to right are Chester Scofield, Alex Scofield, Leslie Lewis, Myron Lewis, Lester Rotherforth, Olive Seeley, Amelia Anderson, Simeon Lanehart, and Louis Anderson. The name Kettletown was so called because the area was bought from the local American Indians for a kettle.

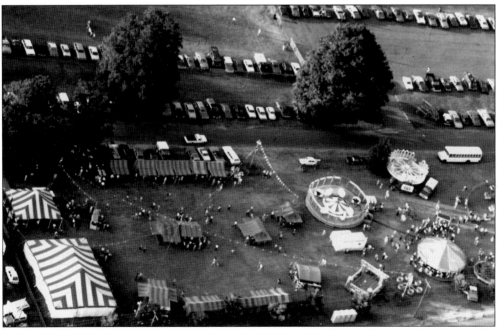

SOUTHBURY FIREMAN'S CARNIVAL. The first carnival was held in 1935 on a plot owned by the Parsell family, which later became the site of Pomperaug Elementary School. Later carnivals were held at Community House Park. The cochairmen one year were Winifred Brinley and famed actress Arleen Francis. The carnivals were held until about 1983.

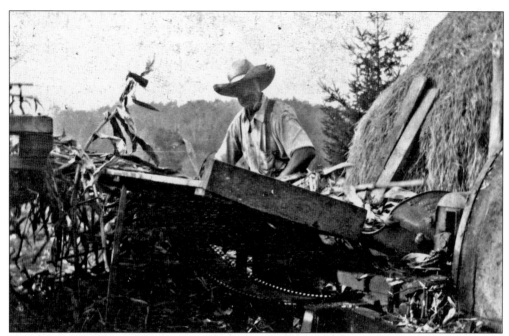

ELMER LEWIS, 1922. In the 1800s, an average New England farm size was about nine acres of meadow, seven acres of pasture, and three or four acres planted with grain. The size of a farm had a direct relationship to family capability to manage without the help of outside labor. Many farms had much larger acreage. The average farm in 1990 had about 461 acres.

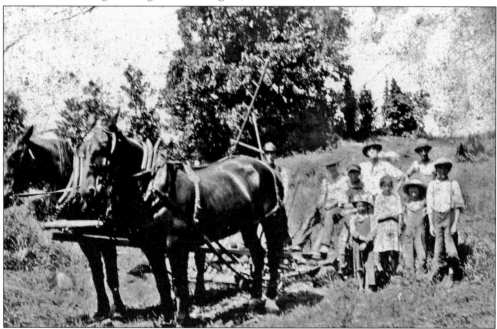

A FAMILY HAYING. The mechanization of harvesting crops was important. The hay baler was developed in the 1930s, and the corn picker invented in the 1900s. The heavy summer labor of manually handling hay was relieved in the 1970s with the development of the baler, which produces the long cylindrical hay balls commonly seen today.

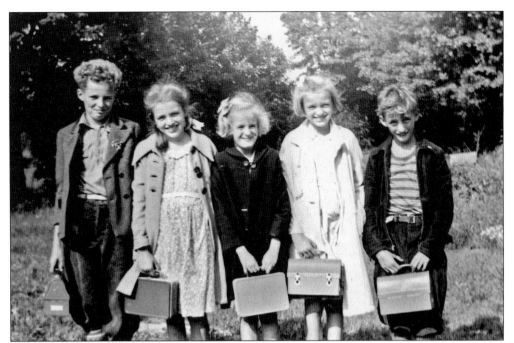

Lewis Children with Lunchboxes, c. 1939. From left to right are Reg, Doris, Inez, Betty, and Bobby Lewis. In 1935, approximately 229 students were attending both the grammar and high school.

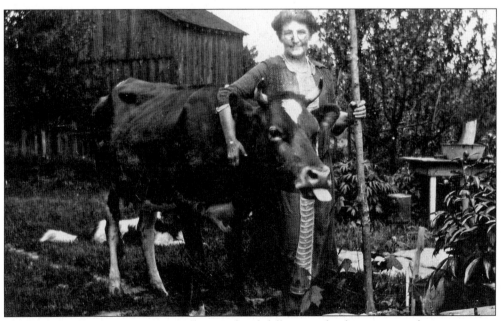

Woman and Cow. Women typically completed different tasks than men: cooking, managing resources, milking the cows, gathering eggs, growing vegetables, tending children, sewing, washing, and mending. The house was the responsibility of the woman. The dooryard of the home was an area shared by men and women; there, the men fixed things and women did the laundry.

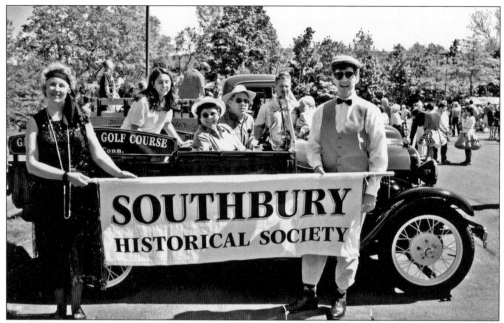

ROARING TWENTIES. This picture shows members of the Southbury Historical Society ready to march in the 1998 Memorial Day parade with Allen Brinley's vintage car. Marching, from left to right, are Catherine Palmer (chair of Southbury Historic Buildings) and Brian Jones (president of the Southbury Historical Society). In the car are Susan Barraco and Carol and David Webster.

HOME OF ANNA PIERCE WARD WITH NIECE, OLIVE PIERCE WEASA. The economy of this rural setting prior to 1773 was primarily dependent on farming. The original settlers drew up an agreement in 1673: "Fundamental Orders agreed upon in order to the settlement of a plantation at Pomperauge."

JENNIE L. TSCHAUDER WITH BUNNY AND CHARLES LAUTENSCHLAGER, EARLY 1900S. Both the Tschauder and the Lautenschlager families were very involved in town and community activities. The Lautenschlagers once lived in what was thought of as the oldest home in town, known as the Stone House or Bronson House. It was built as a fort to protect settlers against warring American Indians.

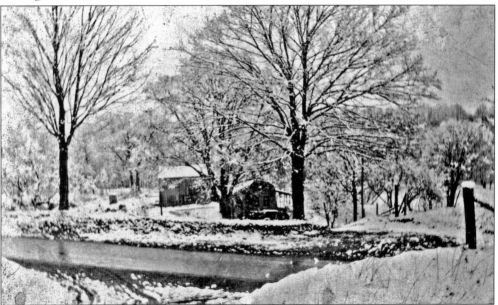

ON ROUTE 67. This winter scene features an early home and a snowbound road near Route 67. Winters were a grave problem for travelers in the time before paved roads and snowplows. The South Britain Congregational Church was built due to seasonal transportation problems in getting to religious services at the Congregational church in Southbury.

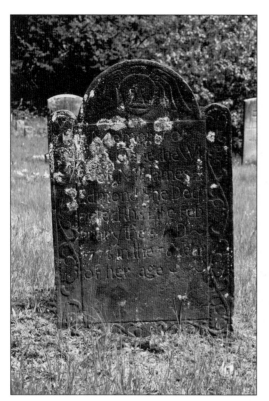

GRAVESTONE WITH DEATH MASK. Some stories found in cemeteries are found in pictures on the stones and not just included on the epitaph. Death's heads, or skulls, were found on gravestones from 1670 to 1770. These figures represented a fear of death and a sense of awe. Angel heads were common between 1740 and 1820. These figures showed a sense of confidence that individuals would find their way to heaven.

GRACE DOROTHY BRONSON SCOVILLE AND EDWARD SCOVILLE SENIOR, c. 1950. Edward and Grace Scoville were married for 73 years. Edward Scoville had many jobs in his lifetime: lumberer, mason, assessor, member of the Southbury Board of Finance, director of the Seymour Bank and Trust, and Southbury representative to the state legislature in the early 1900s. He had one of the finest American Indian arrowhead collections.

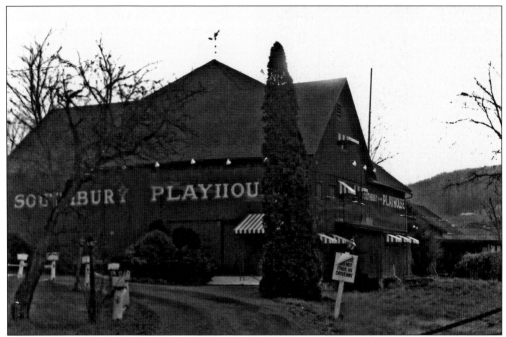

SOUTHBURY PLAYHOUSE. Many big-time actors were attracted to perform at the Southbury Playhouse on summer evenings. The first performance was staged in 1946. One time, resident and television host Ed Sullivan even appeared there. In 1968, Thomas Littleton took over the playhouse. The playhouse was demolished in the late 1980s.

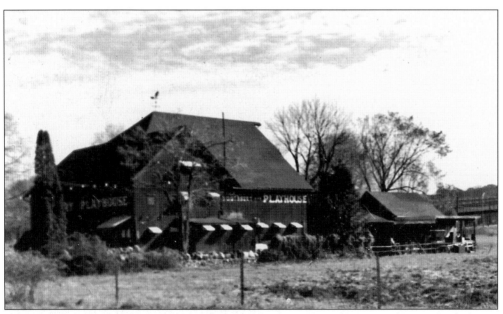

PLAYHOUSE CORNER. The Southbury Playhouse was located at what is now known as Playhouse Corner. This area has always been one of the town's busiest intersections. By 1988, both the playhouse and the Shelton House were the last 18th- and 19th-century structures in the area, built on the old Hicock property. The Hicocks were among the first white settlers in Southbury.

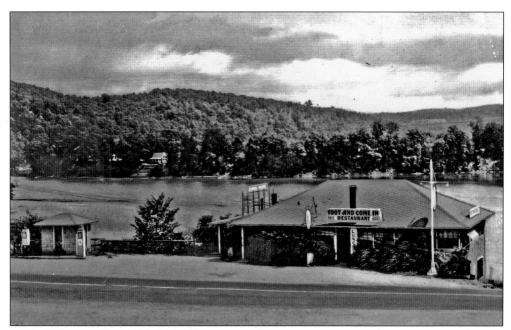

MA'S TOOT AND COME IN. Pictured is the local bar run by Mrs. Hall on Route 6 near Lake Zoar. It was closed in the 1940s. Hot dogs were 10¢, sandwiches 10¢ and 15¢, and a cup of coffee 5¢. The building is currently a private home. The Cantones Restaurant was located nearby.

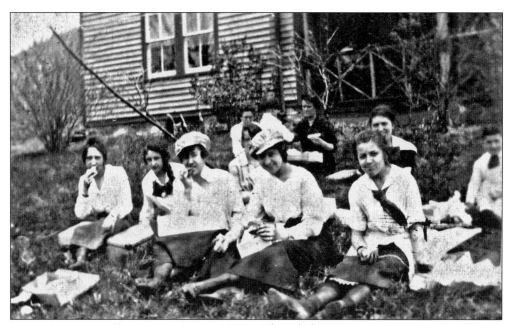

LADIES LUNCHING OUTDOORS, EARLY 1900s. These ladies are enjoying a country picnic, as was the custom in the early days.

Two

WHITE OAK

It was in White Oak that the dissidents from the Stratford Ecclesiastical Society first came to settle Old Woodbury. Later, this part of town became part of Woodbury's daughter, Southbury. The Hinman, Stiles, and Curtis families were some of the first settlers in town. Affluent families received 25 acres. The poorest received 10. Bachelors received 5 acres. Only a fifth of the land was used for dwellings.

STILES BROOK. The waterpower from this brook was harnessed to operate a nearby mill in the 1800s. Members of the Stiles family were descendants of the first settlers who came to White Oak in 1673 from Stratford. Until early 2000, the waterfall from the dam was a beautiful scene for passersby. The dam broke, and although restoration efforts were made, it has not yet regained its appealing beauty.

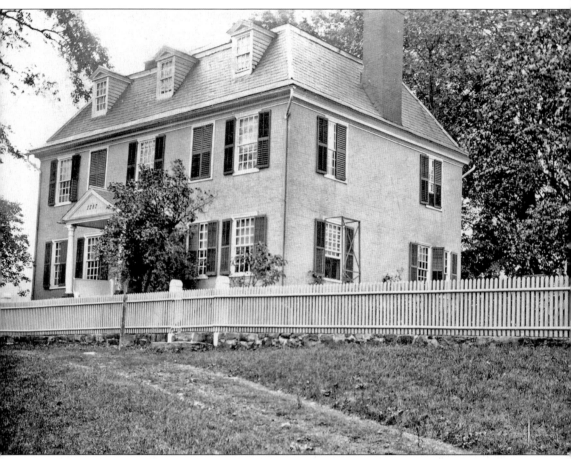

STILES METRIC HOUSE. This stately house was built in 1787 and stands on a rise on the east side of Main Street, about a quarter-mile south of the Woodbury town line. The mansard roof made of slate was an innovation, as was the "upright ell." On the north side, the foundation thickens to seven feet at its base. Benjamin Stiles was a Yale graduate of 1776 who, in 1778, received his master's degree from the same school. He practiced law and owned part of a furniture shop.

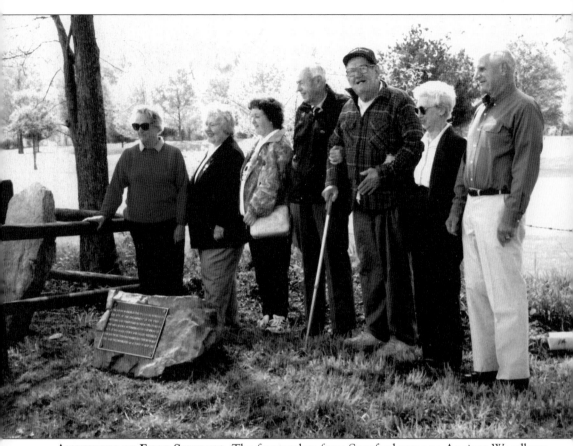

ANCESTORS OF FIRST SETTLERS. The first settlers from Stratford came to Ancient Woodbury, of which Southbury was a part, and rested under a white oak tree at this location in 1673. The site is along Crook Horn Road in the area now called Settler's Park in the White Oak section of Southbury. A commemoration plaque in honor of the first settlers was donated by Shirley Garrigus (McIlroy) and Edmund Schade and was dedicated on May 14, 1996. Some of the descendants of those early settlers are pictured here with the plaque donors. From left to right are descendants Ann Hinman Lilley, Cynthia O'Connell, Mary Morris, Fred Strong, and David Nutting Stiles with donors Shirley Garrigus McIlroy, and Edmund Schade.

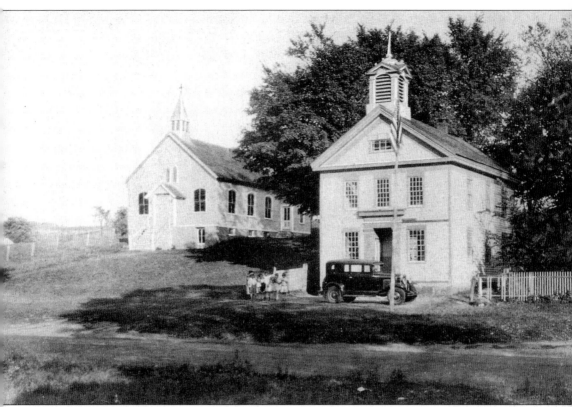

WHITE OAK SCHOOL AND SACRED HEART CHURCH. White Oak School was built in 1840. The old Sacred Heart Catholic Church is seen in the background. Parishioners held their first mass in the new White Oak Church on Christmas Day 1884. Today, a cemetery is located there. Denis Hunihan donated the property for the church. His wife, Delia, would launder and iron the church linens. The new brick Sacred Heart Church was built in June 1958. The first Catholic masses were said in the home of Francis Grant by Rev. James Bohen. The parish was considered a mission community to St. John's in Watertown. Liturgies were given at several times at the railroad station located at the top of Depot Hill. At intermittent intervals, priests from the Waterbury Church of the Immaculate Conception would come to Southbury. In 1884, there were 40 Catholic families in town. The church remained a mission until a resident priest was appointed in 1940. The first pastor was Fr. Cornelius Buckley. By 1958, there were 250 families in the parish.

MODEL POSING FOR WALLACE NUTTING. Wallace Nutting was a famous colorist of platinum prints. This photograph was taken in front of the Benjamin Stiles Metric House, which was built *c.* 1787. Nutting employed many local people. He lived in a home called Nuttinghame from 1906 to 1912. The residence is now used as the Heritage Village Meeting House.

SAMUEL GOODRICH'S GRAVESTONE, WHITE OAK CEMETERY. This gravestone, with an open book motif, is that of Samuel Goodrich, who wrote children's books under the name Peter Parley. He lived in Southbury for a short time but wanted to be buried in "God's Acre where the sun shines and where rain falls upon the grassy mound."

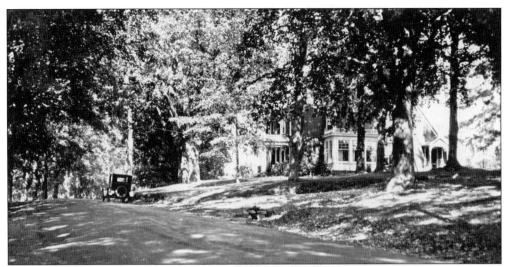

SAMUEL GOODRICH HOME. Samuel Goodrich lived in this home. A popular tale states that the large shade trees at the site were gifts from King George of England. The brick building was erected in 1777. In 1918, the house became the Lutheran home for the aged after being purchased by the Lutheran Inner Mission Society of Connecticut. It was completely modernized in 1954.

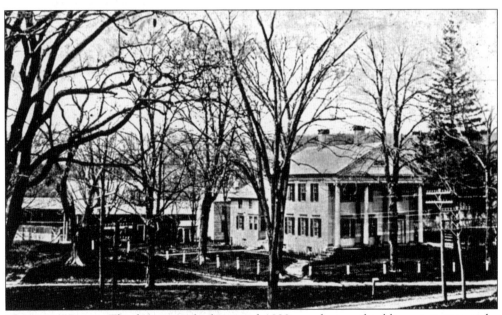

MANSION HOUSE. This home was built around 1829 as a house of public entertainment by Mitchell S. Mitchell in the then popular Classical Roman Revival style. The house has two living rooms, with identical fireplaces and mantels, and a semicircular staircase. The Barber Historical Collection states, "For beauty of situation and superior accommodations, it is not exceeded by any establishment of the kind in any country village in the state."

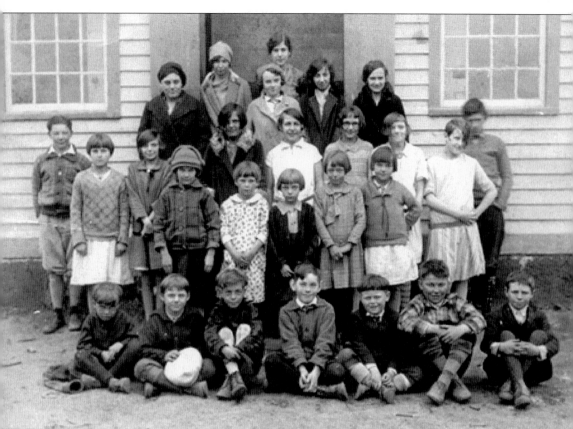

WHITE OAK SCHOOL, 1927–1928. From left to right are (first row) Phillip Bennett, Walter Englehart, Sylvester Bennett, John Shortt, Reginald Bennett, Ralph Matula, and John Smith; (second row) Frank Matula, Stella Nauiokas, Louise Smith, Agnes Shortt, Mary Nauiokas, Gladys Smith, Katherine Keintzler, Adeline Matula, Irene Hoyt, and David Stiles; (third row) Irene Burns, Anna Nauiokas, Katherine Haquist, Elsie Partridge, and Doris Cable; (fourth row) Flora Roberts, Helen Reynolds, Hazel St. Peter, Doris Partridge, and teacher Pearl Newton.

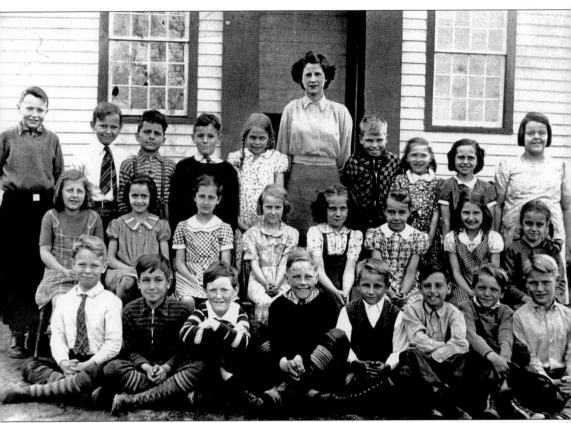

WHITE OAK SCHOOL, 1940. From left to right are (first row) Ernest Earnhardt, Alfie Candido, Edwin Grisgraber, Walter Harrison, Russell Brown, Charles Ingram, unidentified, and Don Bennett; (second row) Arlene Grisgraber, Delores Klesitz, Marilyn Green, Mary Dennis, Jane Hicock, Majorie Wood, Shirley Makl, and Althea Hicock; (third row) George Hennessey, John Petty, Andrew Scoville, Fred Carey, Ellen Hicock, teacher Edna Dumschott, Howard Hicock, Patty Hicock, Kathleen Ingram, and Lorraine Parsell.

Mr. Stiles Collecting Maple Syrup in Kingsland. March was the month for maple sugaring. Some refer to this area, about three acres in size on Route 6 on the way to Woodbury, as Queensland. Records show that at some time there was a natural amphitheater on the southern end of the common. In the summer, on Saturday nights, bands from Woodbury, such as the Pomperaug and West Band, came to entertain.

Three

TRANSYLVANIA, PIERCE HOLLOW, AND THE PURCHASE

Transylvania is named for the Transylvania Brook that runs nearby. Pierce Hollow was named after Deacon John Pierce, an early settler of Old Woodbury who lived on Southbury Street. Pierce's only son moved to the South Britain Parish and was one of the area's earliest settlers in the early 1700s. Seven of his eight sons built homes along Pierce Hollow. The Purchase got its name from a series of land purchases from the local Pootatuck Indians. Some lands were sold more than once.

CHARLES LAUTENSCHLAGER AND SANFORD TSCHAUDER AT STONE HOUSE, EARLY 1920s.
English Colonial authorities proclaimed that well-fortified houses be built for the safety of their families. The first structure built was a log stockade from which a 24-hour lookout was maintained against the American Indians. It has been called the Transylvania Farm and Stone House Farm. It is located against Bronson Mountain, back from Route 172 near the Route 67 junction. It is believed to have been built around 1704, and it is possible that it is the oldest dwelling in Southbury. In 1991, the most recent owners of the house were awarded a plaque by the State of Connecticut, designating it as one of the 176 houses in the state deemed to be the oldest in their respective towns. The Stone House Farm sits on more than 250 acres of land. Its history includes being one of six houses in Ancient Woodbury, of which Southbury was a part from 1673 to 1787. The house was called the Bronson House in the earliest recording by William Cothren in his *History of Ancient Woodbury*, written in 1824. During the 19th century, Nathaniel Smith was the owner. Smith then passed it to his son. The younger Smith's daughter married a Bronson, and the couple also lived in the Stone House. When the Lautenschlager family purchased the home in 1904, it cost $1,006 and included 264 acres, as well as outbuildings. The original structure was approximately 37 feet by 26 feet and had a fieldstone exterior. The interior includes strap hinges on the door and wide floorboards. Exposed beams and a fireplace with a large stone firebox are on the lower level of the house.

JANIE PIERCE'S POND, TRANSYLVANIA, LATE 1940S. Pierce's Pond is now a town park enjoyed by many. The property was sold to the town by Janie Pierce, who taught school for many years in Southbury's district schools. When she sold the land to the town, she requested that it be kept in its natural state. In 1987, the Janie Pierce Park was the second largest park, second to Platt Park.

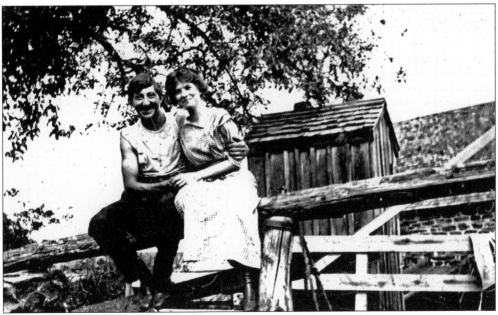

COUPLE SITTING ON SPLIT RAIL FENCE. Pictured are William and Lottie Lautenschlager in the spring of 1914. Many Lautenschlagers grew up in the Old Stone House. Old Daniel Boone and Abraham Lincoln stories mention splitting rails. Early pioneers used these fences to mark boundary lines and to fence in livestock.

Grand List of the Town of Southbury.

October 1, 1895.

288	Dwelling Houses,	$ 96,190
22319½	Acres of Land,	289,397
27	Stores and Mills,	37,000
392	Horses,	14,612
1202	Cattle,	20,190
	Sheep,	1,752
67	Wagons,	2,127
	Farming Utensils,	200
	Clocks,	450
	Musical Instruments,	6,390
	Bank Stock,	39,288
	Manufacturing	6,370
	Investments in Manufacturing,	3,000
	Money at Interest,	6,150
	Money on Hand,	4,200
		$526,929

Indebtedness, $10,750.
Rate of Taxation, 10 mills.

Marriages.--1895.

January 8, George Smith—Viola Clifford
April 24, George W. Morris—Lillie Stoddard.
June 26, Frederick Wentsch—Susan Smith.
September 7, O. C. Shelton—Jane W. Rowley.
November 2, J. B. Richardson—Laura Dawson.

Marriages.--1896.

February 18, Charles Oberstadt—Minnie Tucholske.

Deaths.--1895.

January 1, Susan Castle Bradley.
January 11, Lucy S. Curtiss.
March 21, Amos T. White.

Buy Bedding of J. C. TWINING & CO. 422 00 South Main

GRAND LIST INFORMATION, OCTOBER 1895. There were 288 dwelling houses in town and over 22,319 acres of land. There were 1,202 cattle and 392 horses.

BARNES' Woodbury Directory

FOR 1896,

COMBINED WITH A DIRECTORY OF THE VILLAGES OF

BETHLEHEM, SOUTHBURY, SOUTH BRITAIN AND SOUTHFORD.

Containing a General Directory of Names, Occupations and Residence of the people of the above-mentioned places; also a Business Directory of Leading Business Houses, Town Officers, Courts, Corporations, Churches, Public and Private Schools, Lodges, Societies,

BIRTHS, MARRIAGES AND DEATHS,

Streets, Avenues, etc., and all desirable information about the Town of Woodbury for Citizens and Strangers.

CAREFULLY COMPILED.

PRICE - $1.00.

WOODBURY, CONN.

BARNES WOODBURY DIRECTORY, 1896. Pictured is an advertisement for the directory, which included "names, occupations, addresses of residents, along with business information."

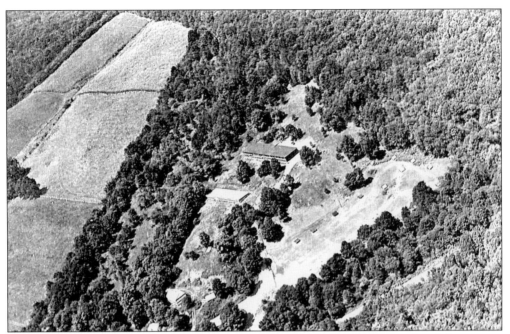

AERIAL VIEW OF PIERCE HOLLOW FARM. The Pierce Hollow Farm was considered the pioneer in the industry for using automated mechanical feeders and egg handlers. The farm had over 19,000 birds at one time.

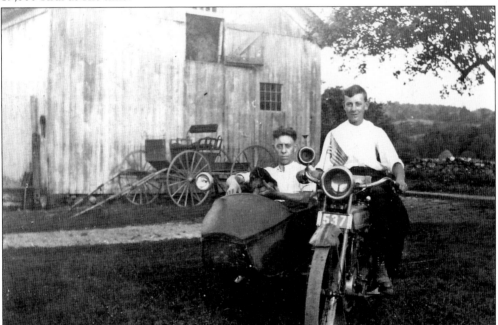

FRED BARNES AND CHARLES LAUTENSCHLAGER ON MOTORCYCLE WITH SIDECAR, 1920S. Various accessories were developed once motorcycles were established in the marketplace. The most visible one, perhaps, was the sidecar, a single compartment attached to the mainframe. It also increased the stability of the vehicle, which was important for military use where there were poor road conditions.

STAND AT PINE TREE SERVICE STATION, C. 1930. The stand once stood on the northwest corner of the intersection of Route 67 and Transylvania Road.

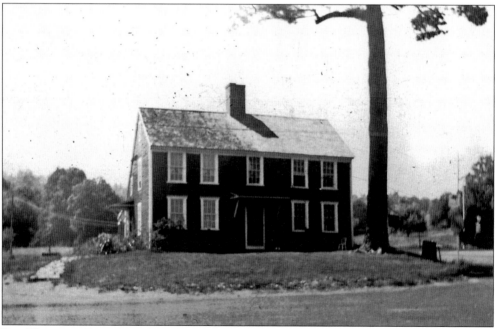

RED HOUSE AT PINE TREE CORNER, ROUTES 172 AND 67. This part of town was named after the towering tree. A hurricane blew the renowned tree over many years ago. When it died, it was at least 164 years old and was reputed to have hidden a Revolutionary War spy at one time. It was about 110 feet tall and 5 feet in diameter, according to a surveyor.

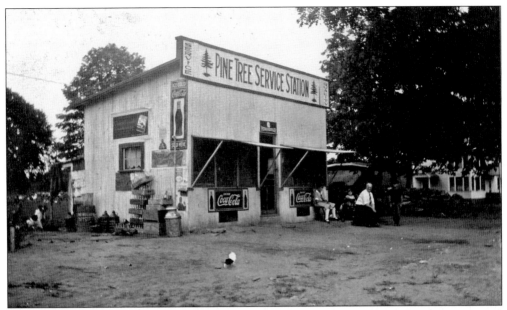

PINE TREE SERVICE STATION, CORNER OF TRANSYLVANIA ROAD, MID-1900S. Several tanneries were located between Pine Tree Corner and South Britain along Transylvania Brook in the early 1800s.

PINE TREE STAND. Candy and ice cream, as well as gasoline, were sold at this site. A cider mill was also located on the property. According to local history, a catsup factory was nearby.

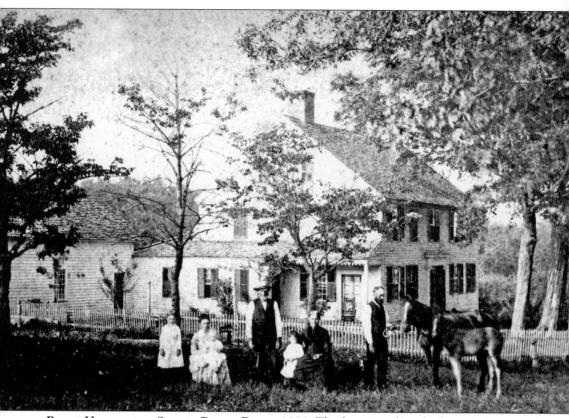

Platt Homestead, Spruce Brook Road, 1888. This homestead was built in 1799. Pictured are Edward A. Platt and his wife, Ellen Barnes Platt, son Willis Platt and his wife, Margaret Burke Platt, and children, Eunice Platt Mitchell, Sara Platt Robinson, and Edward Platt, who was born in 1887. The homestead is still in the Platt family and is a dairy farm. In the fall of 1895, there were 288 "dwelling houses" in town. Ed Platt served as vice chairman of the Connecticut Farm Bureau.

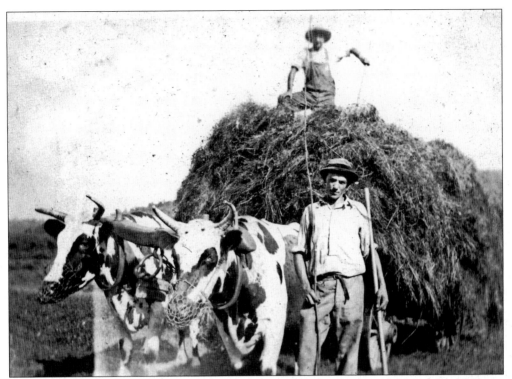

HAYING. The larger farms in town were in central areas: the Purchase, Pootatuck, and Pierce Hollow. Most of these farms produced milk that went to Hubbell's Creamery in Southford or to New Britain on the 11:00 A.M. train. Most of the milk sent to New Britain was for the Sealbright Dairy. More people went into the dairying business after the dam at Stevenson was built.

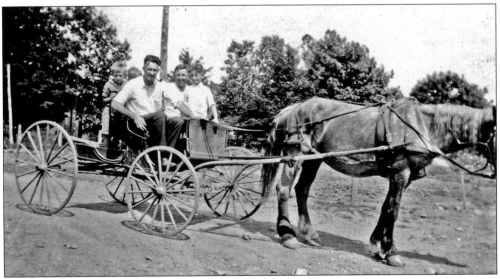

RIDING THE WAGON. Pictured here are George Tschauder, Frank Loren, and children in 1929. In 1928, the George Newtown Veterans of Foreign War Post No. 1607 was started. That same year, Southbury's first Boy Scout troop (No. 60) was also formed.

JANIE PIERCE'S CLASS, EARLY 1900S. Shown are students in Janie Pierce's class. Pierce taught in several of Southbury's early 11 school districts.

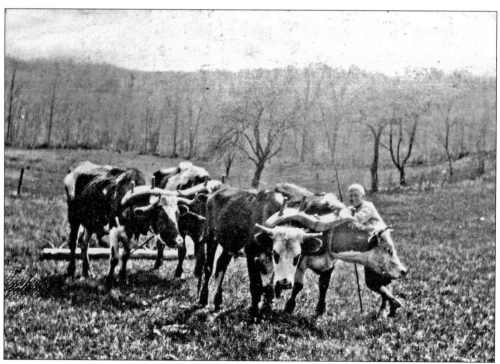

OXEN. For over 250 years, oxen, people, and horses supplied the power that ran farms.

BUILDING PIERCE HOLLOW FARM CHICKEN COOPS ON ROUTE 172. This picture was taken around 1950, and it shows the coops being built by Leroy Townsend and Bill Lautenschlager. The coop's dimensions were about 80 by 160 feet.

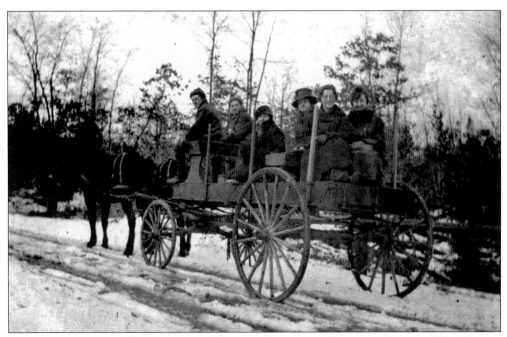

RIDING ON ANCIENT HORSE-DRAWN WAGON, PINE TREE CORNERS, EARLY 1900s. Wagons were common conveyances prior to the invention of the automobile. Winter months, as well as the muddy season, created disruption for travelers.

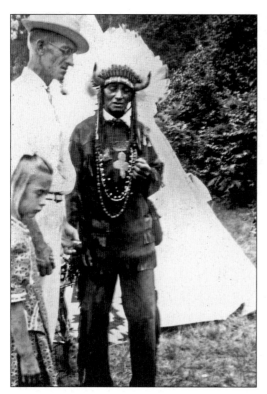

HAROLD A. BENEDICT AND NANCY
BENEDICT (GREIST) WITH SCHAGHTICOKE
INDIAN, WEST SIDE OF THE HOUSATONIC.
Housatonic is an American Indian word
that means "place beyond the mountains."
The local Pootatuck tribe had an entryway
from South Britain by the way of the
Indian Gate, which is on what is now the
Mountain Valley Equestrian Center. The
Pootatuck Indian Trail is by Flood Bridge
Road and ends at the Bent of the River. The
Pootatuck Indians moved up to Kent after
they sold their land. The Mitchell family
bought their village.

BILL BLUM IN HIS GARDEN AT HIS
1700-ERA HOUSE IN THE PURCHASE.
Bill Blum was active in town affairs and
a member of the Southbury Historic
Buildings Commission. He was a
renowned artist.

Sycamore Tree, 1940.

The McAllister family's ancient sycamore tree was designated as one of Southbury's notable trees by the Southbury Historical Tree Restoration Committee in the late 1990s. Today, the trunk's circumference exceeds the outstretched arms of two men trying to encompass it. It was once featured in *Yankee* magazine. According to family oral tradition, it was living when Abraham Lincoln's death was announced throughout the land by the ringing of church bells.

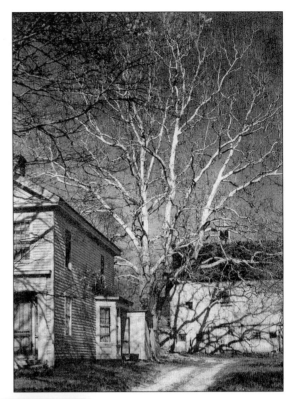

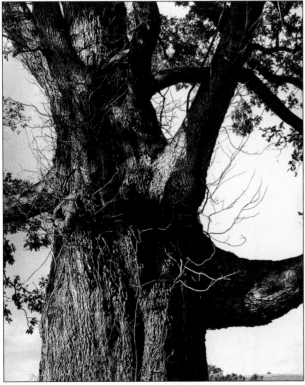

Ancient White Oak at Platt Farm. This heritage tree was located on the Edward Platt Farm on the Spruce Brook roadside. In 1957, it was 23 feet 5 inches in circumference at a point some 4 feet above the ground. It was taken down in 1968 because of broken limbs and water damage. A heritage tree, or notable tree, is named for remarkable size, shape, species, age, and historical significance.

BLUM HOUSE, BUILT IN 1700S, SOUTH PURCHASE. The records from the 1800s state that the fourth lot in the third tier was transferred from Lemuel Sanford from Samuel Wheeler "with apputences." The Southbury assessor card shows the dwelling in 1810, barn in 1850, and shed in 1920.

LOOKING DAPPER. Posing here is William Lautenschlager.

Four

SOUTHFORD

The Southford section of Southbury has been called "Out East," and part of it is known to natives as Union Village. Southford is in the southeastern area of town, beyond George's Hill. The site, once known as one of Southbury's early manufacturing areas along Eight Mile Brook, now includes the state-owned Southford Falls State Park. Early residents included blacksmiths, mechanics, shoemakers, hatmakers, tailors, carpenters, spinners, weavers, nail makers, rope makers, and coopers, known for their barrel-making skills. Much like doctors who made house calls in later years, these craftsmen went to the homes where they were hired to ply their crafts. Legend has it that the shoemakers called these house calls "whipping the cat." The 1800s were a time when farming was joined by these many occupations, as well as workers employed in area factories.

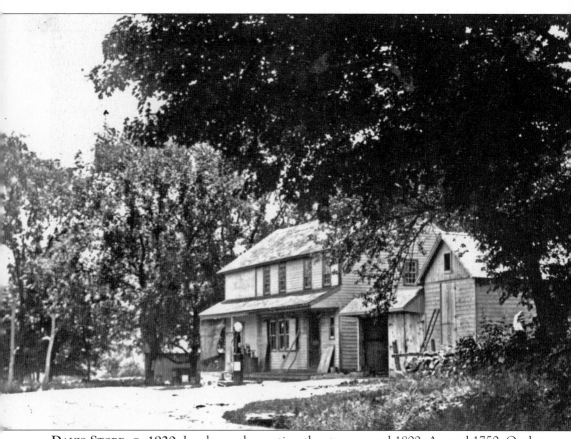

Davis Store, c. 1920. Land records mention the store around 1800. Around 1750, Quaker Farms Road was built and the Oxford Turnpike after 1793. Rockey's 1892 *History of New Haven County* lists the merchants from 1800 through 1890: Robert Ferguson, H. V. Porter, Horace Oatman, E. Pardee, H. S. Wheeler, W. J. Oatman, and C. P. Tappan. The Davis family purchased the store from the Oatmans in 1895. It is listed in the Connecticut Book of Historical Buildings. Packaging was used less than today. Sugar was stored in a large covered barrel under the counter. Molasses was in a barrel with a pump. Kerosene oil was in a large drum. One side of the store contained clothing and hardware. The clothing was mostly men's work clothes, shoes, and ladies' stockings. A few bolts of cotton cloth were available, as were needles and thread. Hardware was seasonal, in that axes were sold in the winter and scythes in the summer. Nails were kept in small kegs in the back and were sold by weight. Two routes were run to take orders for groceries: Quaker Farms and Christian Road. Bill and Kayanne Davis own and operate this store today.

OSBORNE GRAIN COMPANY, C. 1930. The barn stood on the property of T. F. Wheeler, which was also the residence of his cousin Clark Osborn. In the foreground are members of the Symington and Kane families.

LOVDAL FAMILY FARMHOUSE. The 50 adjoining acres to the Lovdal family farm on Hull's Hill Road have been purchased by the Southbury Land Trust for preservation of open space with federal, state, town, and private funding. The original owners of the farm in the 1700s were the Tomlinsons. It has been in constant agricultural use since that time.

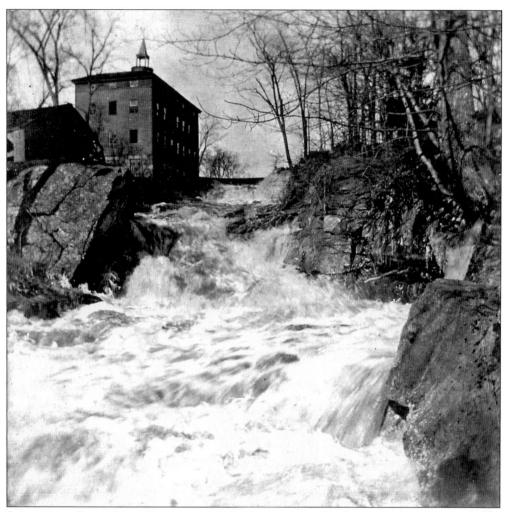

SOUTHFORD PAPER MILL FALLS AND LOCK HOUSE. Enos Candee and Adin Wheeler leased water rights in the early 1800s to various businessmen, including metal smiths Dyke, Steel, and Lum. New factories included ironworks, Candee's Fulling and Carding Mills, and Down's Button Factory. A dam was built at the base of the gorge where the road crossed the brook to capture excess water. A millrace carried the spent water where another dam created a reservoir to make additional power. The mill underwent many changes. A depression hit after the War of 1812. Technological advances and competition hurt profitability, driving the need for invention. Vats previously used for wool-fulling processing were used for preparing paper products made from old rags. T. Wheeler turned to making paper on the Jeremy Brook millrace. Many years later at the same site, the Diamond Match Company introduced the non-poisonous match and the matchbook.

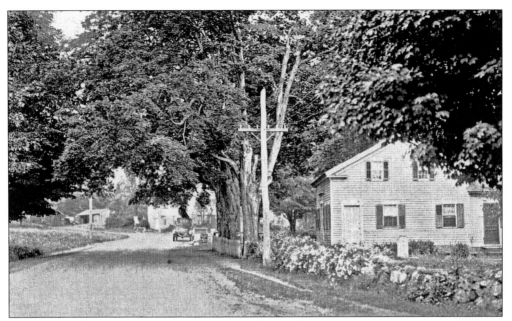

SOUTHFORD CENTER, LOOKING NORTH AT UNION CHURCH. In construction in 1825, the church was used occasionally by Episcopalians, Baptists, and Congregationalists. From 1830 to about 1845, Methodists met here, holding services conducted by both local and circuit preachers. Many dated their conversion from the time of the 1830s Great Revival. The property previously held a still house there. The surrounding area was then known as Union Village.

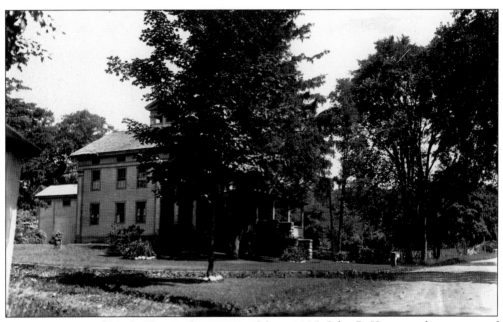

SUPERINTENDENT KING'S HOUSE, SOUTHFORD MILL, 1925. John B. King was the manager of the Diamond Match Company. He owned a car that he drove six miles north to Lake Quassapaug to regulate the water flow in Eight Mile Brook for the factory. The mill ran 24 hours a day, except for breakdowns. King was manager for a long time until the mill closed around 1920.

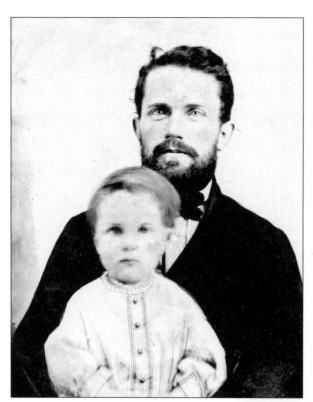

AN EARLY-1900S DAGUERREOTYPE OF HENRY B. DAVIS AND SON JOHN. Henry B. Davis was one of the early owners of the farm that he sold in 1918 to the Lovdal family. The Lovdals in turn owned it for almost a century. Henry's only son, John, died at age 18 in 1918 of a disease contracted in the armed services in World War I in Panama.

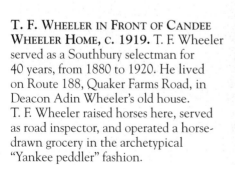

T. F. WHEELER IN FRONT OF CANDEE WHEELER HOME, C. 1919. T. F. Wheeler served as a Southbury selectman for 40 years, from 1880 to 1920. He lived on Route 188, Quaker Farms Road, in Deacon Adin Wheeler's old house. T. F. Wheeler raised horses here, served as road inspector, and operated a horse-drawn grocery in the archetypical "Yankee peddler" fashion.

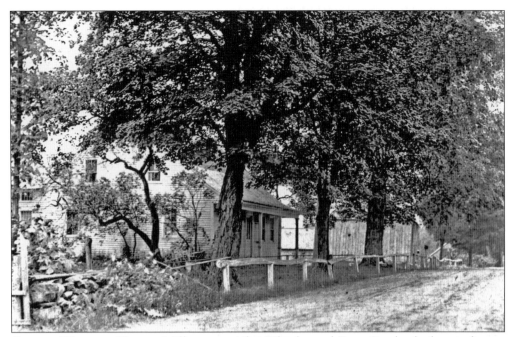

CANDEE WHEELER HOUSE. Mill owners Adin Wheeler and Enos Candee built twin houses near the falls prior to 1799. Wheeler invested heavily in the development of Southford, and his home served as residence to eight generations of his descendants, including his son-in-law and partner Samuel Candee Jr. and town first selectman T. F. Wheeler.

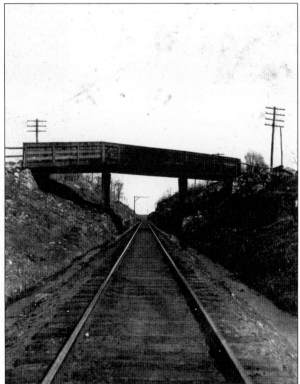

SOUTHFORD RAILROAD. The New York and New England Railroad went through Southford and Southbury. At one time, the Southbury station was called the Pomperaug Valley Station, and the Southford Station was called the Southbury Station. In 1948, the former New York and New England Railroad between Hawleyville and Waterbury was abandoned. The railroad bed, shown here around 1902, passed under the road, which is now on Route 67. It is maintained by the State of Connecticut as a recreational bridle trail.

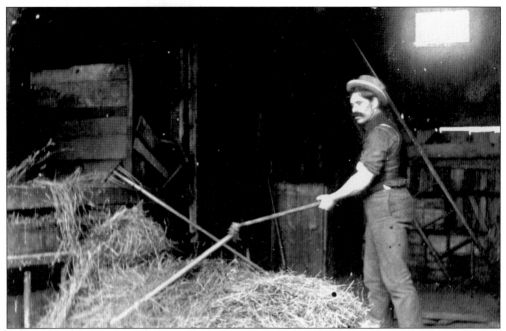

WORKING HARD IN THE HAY BARN. The man pictured is thought to be Charles Sheperd. After the American Revolution, Captain Candee manufactured scythes in town. Farming changed with the mechanization of tools, and crops were no longer processed entirely by hand. Plows, rakes, and balers were pulled by tractors.

A WOMAN'S WORK IS NEVER DONE. Early farmers experimented with plants brought from England, such as blue grass and red and white clover. In the early 1700s, herd grass, known today as timothy grass, was used. It was listed as the most important New England hay grass in 1950.

Five

SOUTH BRITAIN

South Britain was a part of Ancient Woodbury. The charter that made Southbury a town became effective on the second Thursday of May 1787. The document stated, "Upon the Memorial of the Inhabitants of the Societies of Southbury and South Britain and that part of the Society of Oxford that is within the limits of Woodbury. Praying to be incorporated into a separate distinct Town Ere, as per Memorial on File." It further stated that it was resolved that those inhabitants within those limits were incorporated into a separate and distinct town by the name of Southbury. It continued that the town would have the same powers, rights, privileges, and franchises of every kind as all the towns in the state now have and enjoy. Southbury expected that it would be restricted to one representative in the General Assembly. The document was dated June 11, 1787, at Southbury and signed by Edward Hinman, moderator. Shadrach Osborn was chosen as the town's first selectman. Other selectmen were Amos Johnson, Nathan Curtiss, and Edward Hinman.

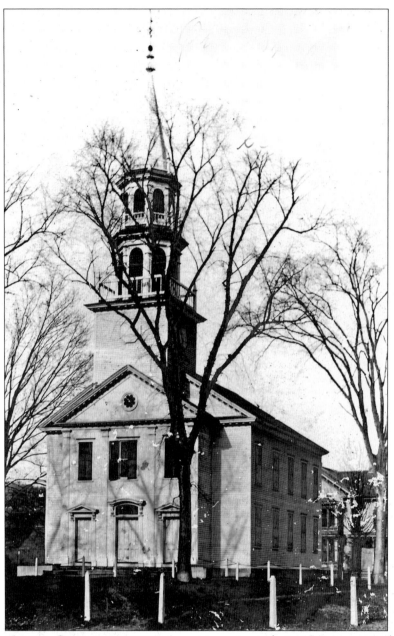

CONGREGATIONAL CHURCH, C. 1906. A petition was made in 1761 to create the second Ecclesiastical Society of Southbury. The origin of the South Britain Congregational Church dates back to 1766, when residents in this section of town decided that traveling in the winter months to the United Church of Christ on the north side of Southbury was too difficult. They first met in the home of one of the members and started work on a modest structure without belfry or steeple, which was built between 1770 and 1786. Some of the materials from this earlier structure were used in building the new church when the present South Britain Congregational Church, still in use, replaced it in 1825. In 1825, preaching service was at 10:45 A.M. and Sunday school at noon. Major alterations were done in 1869. In 1975, the congregation purchased the only true pipe organ in any church in town at that time.

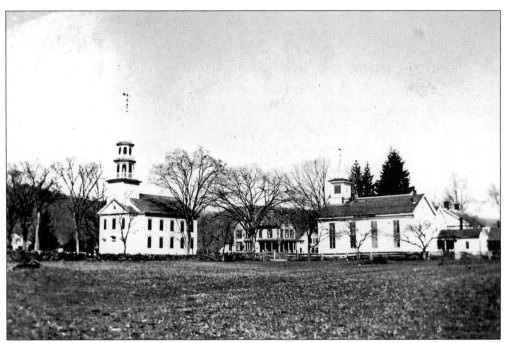

DOWNTOWN, C. 1907. There are 36 major contributing buildings in South Britain's historic district. Buildings include the Georgian, Federal, Greek Revival, Italianate, Queen Anne, and Colonial Revival styles.

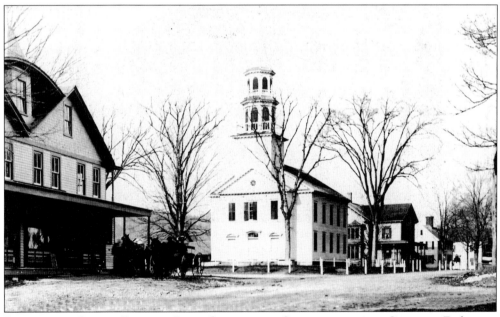

DOWNTOWN SOUTH BRITAIN POST OFFICE AND CONGREGATIONAL CHURCH. Early post offices were in the local general store. The Congregational church was built in 1825 to replace the first meetinghouse, which was built 40 years earlier. When constructed, it conformed to the Federal style but was later changed when the Renaissance Revival arrived.

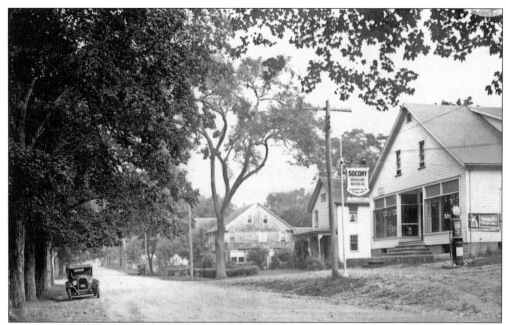

MAIN STREET, SOUTH BRITAIN. This gas station prominently displays a Socony sign. The advent of the automobile displaced the horse and wagon. Gas stations replaced most of the blacksmith shops.

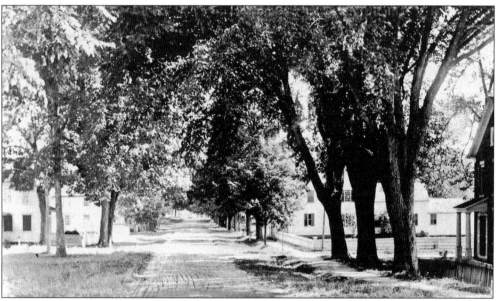

MAIN STREET, SOUTH BRITAIN. In 1986, the federal government recognized South Britain for listing on the National Register of Historic Places. The South Britain area of Southbury is located at the Bent of the Pomperaug River, where waterpower was developed with the construction of a dam. As in Southbury, many small businesses began with the use of this available resource. This peaceful community was the first center of government for the town of Southbury. The town's first town hall was located in the center of town. A general store with post office served the citizens from the farming community, as well as town residents.

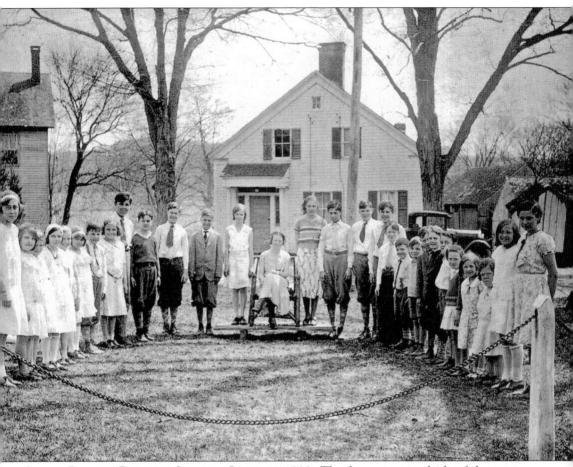

SOUTH BRITAIN DISTRICT SCHOOL, CLASS OF 1929. The first governing body of the town was the Southbury Ecclesiastical Society. The society's mission was to instruct the public and improve appropriate morals. School societies followed and were governed and paid for by parents until 1795. At that time, a law was enacted that the direction would emanate from the town governing board. South Britain School was one of Southbury's 11 district schools. In 1941, only six of the original districts remained. From left to right are Dorothy Dickenson, Agnes Makl, unidentified, Mary Treat, two unidentified students, Myron Pierce, Vera Norton, unidentified, Henry Lovitz, Lloyd Kozenski, Leslie Hatstat, unidentified, Anna Mae Platt, an unidentified teacher, Olive Manville, Clarence Pierce, unidentified, Leo Kozenski, Buddy Frank Roswell, Donald Hatstat, unidentified, Paul Makl, unidentified, Alice McConville, Bertha Grisgraber, Eleanor Munson, Thalia Munson, unidentified, and ? Mclaughlin.

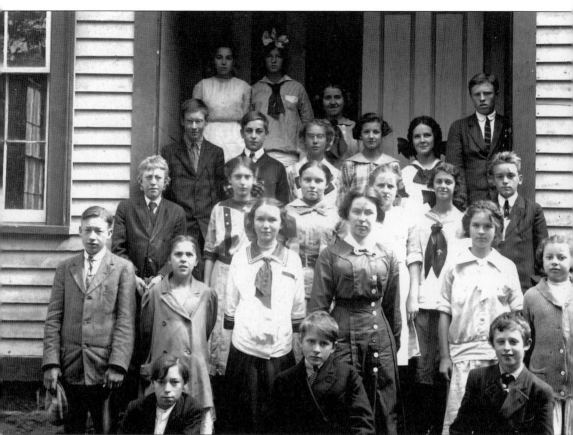

Old Select School at Old Town Hall, 1913. Seen here are students of Florence Southwick's class. From left to right are (first row) Fred Spencer, Charlie Hicock, and unidentified; (second row) Otis Harrison, Florence Spencer, Gertrude Perkins, Florence Southwick, Catherine Stone, and Alice Eriksson; (third row) Arthur Louis, Martha Scoville, Ovaline Manville, Marguerite Beecher, Bernice Hubbell, and Simeon Lanehart; (fourth row) Gregory Cassidy, Harold Benedict, ? Hicock, Anna Wilson, Winifred Williams, and William Fleming; (fifth row) ? Spencer, Carolyn Pierce, and Beatrice Beecher.

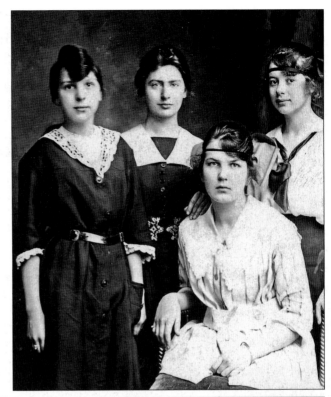

CAMPFIRE GIRLS IN SOUTH BRITAIN, 1917. From left to right are Winifred Williams (Brewer), Florence Spencer (Wilcox), Martha Scoville (Benedict), and Alice Erickson. The members of this national organization are girls from the ages of 7 to 18. Luther Gulick, M.D., and his wife, Charlotte Gulick, founded Camp Fire Girls in 1910 as the first nonsectarian organization for girls in the United States. In 1975, membership was expanded to include boys. Headquartered in Kansas City, Missouri, Camp Fire USA currently serves nearly 750,000 children and youth annually.

POND IN SOUTH BRITAIN, C. 1908. Children enjoyed swimming in this pond in the back of the Hawkins Manufacturing Company. In 1853, a stock company, largely owned by the Pierce and Platt families, formed a waterpower company. At a cost of some $17,000, a dam was built across Transylvania Brook upstream from its confluence with the Pomperaug River at the Bent of the River. To this pond (thus formed) the water of the brook was diverted from the Pomperaug River by means of a small diversion canal (remains of which are still visible). The pond covered about 60 acres and produced a fall of 20 feet. It had a potential of 300 horsepower. In 1861, the dam broke and the pond went with it, along with the stockholders' investments and dreams. The pond has since been known as Lake Disappointment.

MAIN STREET, SOUTH BRITAIN, C. 1909. From early on, South Britain became the industrial section of Pomperaug Plantation, with the Southford area also utilizing the available waterpower in its section of town to be equally productive with manufacturing. In the 1860s, over 60 small factories and shops were contributing to the town's economic growth.

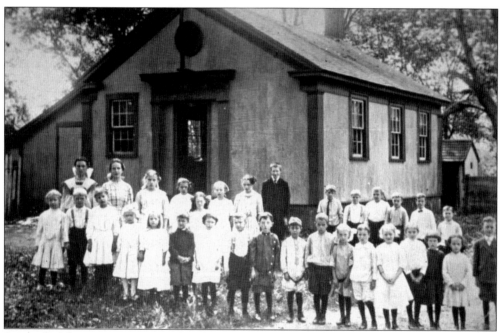

SOUTH BRITAIN DISTRICT SCHOOL, NOVEMBER 1912. From left to right are (first row) unidentified, A. Manville, L. Stilson, unidentified, M. Stilson, A. Fleming, F. Bowers, P. Hobbell, J. Anderson, E. Kiel, C. Hawley, F. Manville, Fred Spencer, unidentified, J. Mitchell, and Niles Erikson; (second row) Helen Mitchell, Winifred Williams, Ovaline Manville, F. Spencer, Alice Erikson, Elizabeth Cassidy, Mary Benedict, Gregory Cassidy, Charles Hicock, Charles Manville, George Manville, Fred Fleming, Wesley Hubbell, and Andrew Scoville. The teacher was Nellie Bourke.

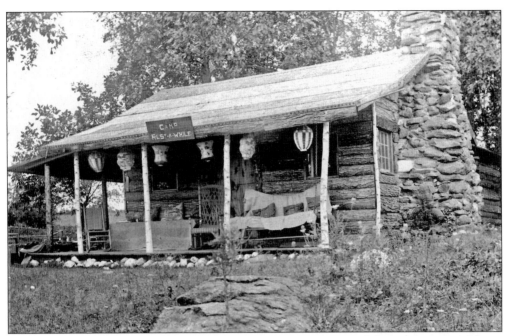

CAMP REST AWHILE, C. 1917. Camps were an important part of American citizens' lives. Families turned to outdoor recreation, as it was affordable as well as enjoyable. Camps for families were popular, as were camps for organizations such as Girl Scouts, Boy Scouts, and Camp Fire Girls.

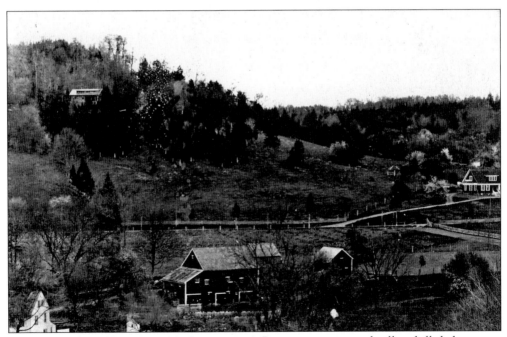

FROM BRADLEY'S HILL, BAKER'S CAMP, 1916. Pretty waterways and rolling hills led many to camp in South Britain.

RUTH HARGER SCOVILLE'S CHILDREN. Ruth Scoville's four children are Grace Lillian (standing) and, from left to right, Edith Elizabeth, Alice Louise, and Sydney Smith Scoville.

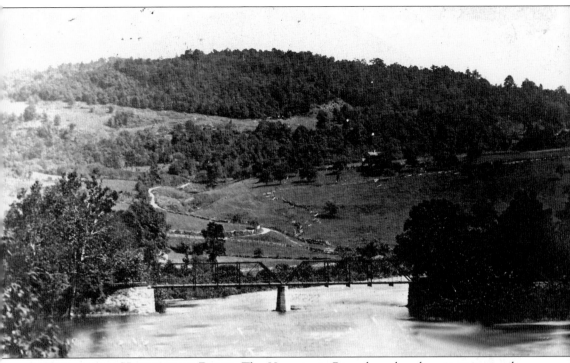

A VIEW OF THE HOUSATONIC RIVER. The Housatonic River has played an important role in the everyday life of Southbury residents. It is considered as one of the "hardest working" rivers in America. This watercourse extends over 115 miles from its headwaters above Pittsfield, Massachusetts, to Long Island Sound at Stratford. The harnessing of power from this river by the Connecticut Light and Power Company resulted in four hydroelectric plants along its course. Two of the dams that were built at these sites created Lake Zoar and Lake Lillinonah. These areas opened up Southbury to vacationers and thriving businesses that were associated with boating, fishing, and water-related activities. In addition, the generator located on the Southbury side of the Shepaug Dam has been an important tax aid to the town.

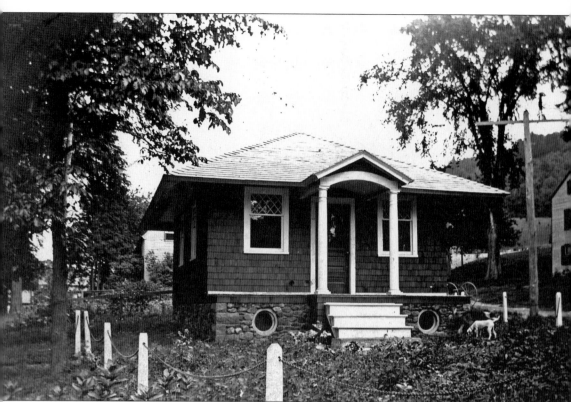

SOUTH BRITAIN LIBRARY. In 2004, the South Britain Library celebrated the 100th anniversary of its beginnings as the first public library in Southbury. Contractor A. H. Wilson built the library at a cost of $746 in 1904. It served as the town's only public library until 1969, when the present library was built on Main Street South. Over 1,000 books were transferred from this charming building to the new library. Histories, reference books, and literature were left behind. In 1983, the Southbury Historic Buildings Commission was appointed to preserve and maintain this historic building. It is now the Library of Local History and Genealogy. Southbury Historical Society volunteer librarians Mary Perry and Kay Thorpe preserve and care for the book collection. The one-story building combines both rustic and Colonial Revival styles and is 20 by 30 feet with a hipped roof. The cobblestone foundation has rondel window panels.

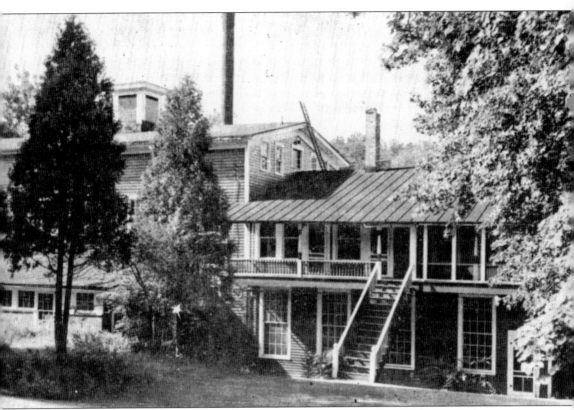

HAWKINS MANUFACTURING COMPANY. The company claimed to be oldest American game trap manufacturer. At one time, it was said that you could not find a fur trap in Canada that did not have a South Britain name on it. Ira Hawkins opened the manufacturing company in 1895 to make brass tubing. This was discontinued, and at various times, organ springs, cowbells, tacks, and steel animal traps were manufactured here. In the late 1960s, Hawkins sold the company to the Southbury Manufacturing Company. A dam nearby powered the flume for the factory. The first dam was built with wood, but it was later replaced by stone. A sluiceway from the dam powered other factories and led into a pond that later fed what was known as Lake Disappointment. The flood of 1955 knocked down part of the dam.

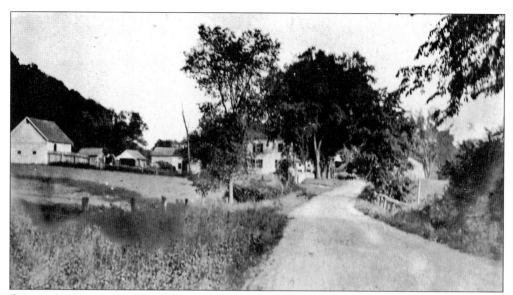

CENTER OF SOUTH BRITAIN, MAIN STREET, 1915. The home of Edward A. Scoville Sr. and Grace Scoville is on the left of Main Street. In the latter part of the 20th century, the Arthur Houle family converted this home into apartments.

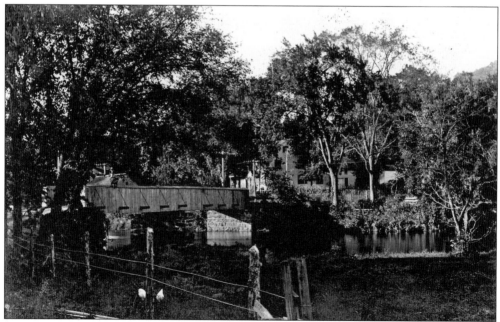

BRIDGE OVER POMPERAUG RIVER. This bridge was called Bradley's Bridge and was located on Route 172. Pomperauge was an American Indian chief.

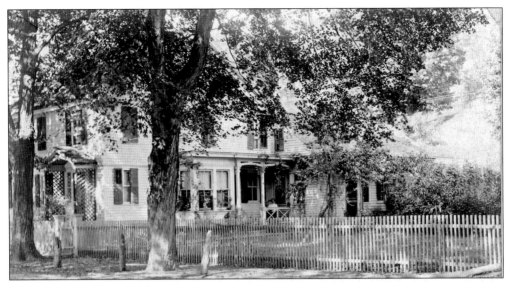

HOUSE IN SOUTH BRITAIN. This house is an example of the twin-chimney, central hall Georgian-style home. This is the most prevalent style in South Britain. Sometimes a Charles Addams–type detail of porticos and cornices was added. Federal-style homes evolved from the Georgian style, with characteristic sidelights and fanlights.

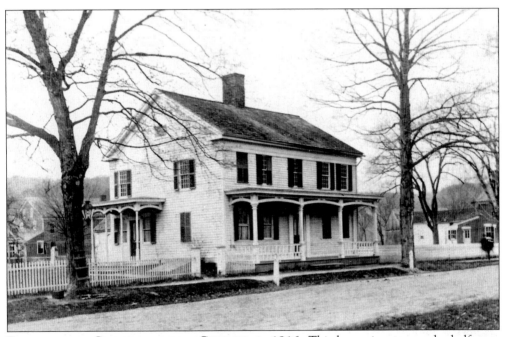

PARSONAGE OF CONGREGATIONAL CHURCH, C. 1916. This house is a two-and-a-half-story building with upper and lower attics. Four fireplaces utilize a huge central chimney. The house has many of the original wide-board pine floors, windows, hinges, and doors.

MAN WORKING IN SOUTH BRITAIN CREAMERY. In early 1895, work began on a new creamery in town. Ice plows, pipes, tongs, and assorted equipment was brought from the Sage Creamery in Stepney. When the new creamery was finished in the summer of that year, water was brought in by lead pipes from the springs on Rattlesnake Hill. In 1897, the building housed over 260 tons of ice. The creamery sent milk and cream to New Haven. Parts of the foundation can still be seen today.

METHODIST CHURCH, c. 1906. This church was built in 1832 and enlarged in 1851. Services were held in George's Hill School until the society grew. The first Sunday school class was held in 1829. The South Britain land was donated by Erasmus Pierce, who was the father of Rev. David Pierce, the minister in 1875. The church was built in a classic Georgian style. Its front elevation illustrates simplicity common to the style.

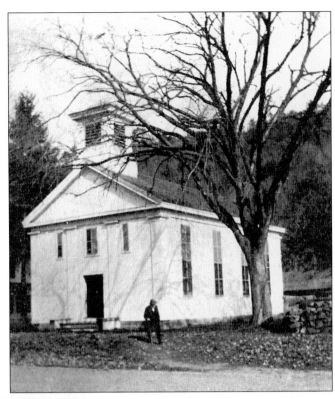

SHUTTERS HANGING OFF METHODIST CHURCH. When the church closed in 1941, it fell into disrepair. It was deconsecrated and sold that year to the McCarthy family, who lived in the house next door.

113

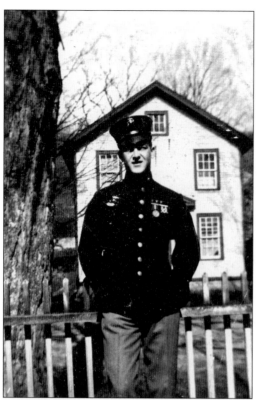

U.S. Marine in Front of Old Town Hall, 1940. Harold Arthur Benedict stands in front of the town's first town hall, which opened in 1874. The old town hall is now a museum. It was saved from demolition in 1972. The Southbury Historical Society uses this building to house Southbury's memorabilia and to present programs and displays for the citizenry to learn about Southbury's history.

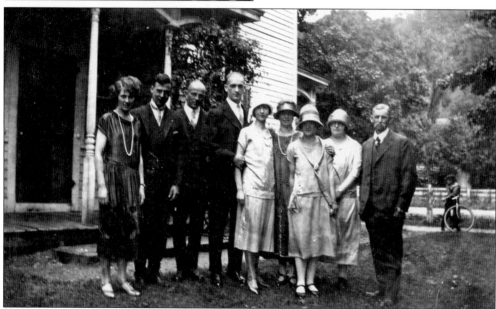

Marriage of Harold Arthur Benedict and Martha Scoville, 1925. This photograph was taken at the Ambler's house, which was located three doors down from the Congregational church. Included in the photograph are Jessie Pierman, Earl Pierman, Howard Terrill, Grace Terrill, Grace Benedict, Mary Benedict, Ed Ambler, and Philip Scoville (on the bicycle). In 1895, only five marriages were recorded in Southbury.

Six

LAKESIDE

Lakeside added a new dimension to the town of Southbury. Rivers, streams, and brooks were natural resources and the lifeblood of this community. The early American Indian settlers and the Stratford settlers depended on the waters for transportation, fishing, and—most importantly in the development of the town—the waterpower that generated energy for running small factories. Lakeside was a man-made wonder. The Connecticut Light and Power Company built four hydroelectric plants along the Housatonic River. The dams that were constructed made the power plants function. The lakes that resulted—in particular, Lake Zoar and Lake Lillinonah— became main attractions to visitors to the area. All of the water sports provided entertainment and relaxation to vacationers. The economy also improved as local merchants profited from the business the summer families brought to Southbury.

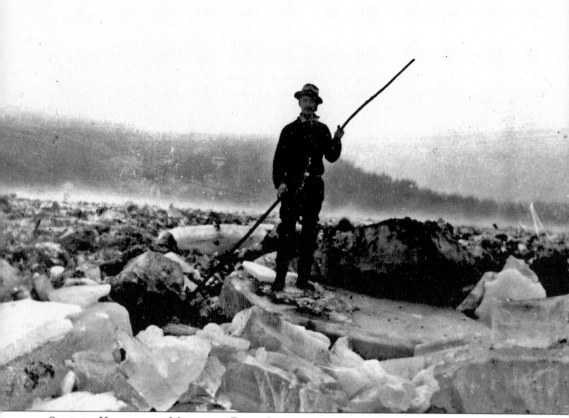

STANLEY KOZINSKY IN MIDDLE OF RIVER JAM BETWEEN LAKESIDE AND HALL'S, 1936. Harold Arthur Benedict wrote, "Within half mile of Lakeside club house, had to walk rest of way to Lake Zoar on account of washed out roads. Walked about a mile and half on smooth ice of river toward Bennett's Bridge. Boards, broken lumber, logs, and junk of all description mixed with huge cakes of ice all jammed together." Hall's was a local bar run by Ma Hall on Route 6 by Lake Zoar. It was closed in the 1940s. Nearby was Cantone's Restaurant, which had its name painted on the roof. Pilots would fly over in World War II and use the building to identify that their path was near Lake Zoar.

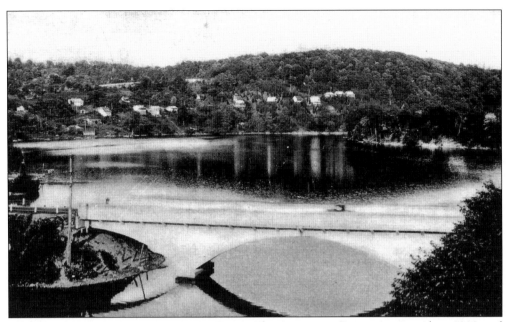

FISH ROCK DEVELOPMENT ON LAKE ZOAR. The Stevenson Dam was erected in 1919 and created Lake Zoar. Summer brought 70 additional families to town to the play in the areas of Lakeside, Oakdale Manor, Berkshire Estates, Fish Rock, Cedarland Park, and Russian Village. Some land along the Pomperaug and Lake Zoar was sold in small lots for as little as $25 a parcel. The lot dimensions were 25 by 50 feet.

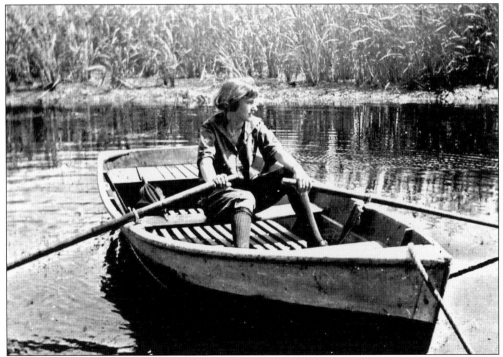

ENJOYING THE BEAUTIFUL DAY. Summertime leisure was a part of vacationing along the lakes. Many visitors returned annually to this getaway from city living.

HIGHWAY NEAR LAKE ZOAR, C. 1949. Many who bought summer homes were attracted to the area during vacations and later made Southbury their permanent residence. Lake Zoar gave Southbury a shoreline of about eight miles.

CAMP POMPERAUG, 1930S AND 1940S. This was a recreation area used by the Boy Scouts. Connecticut Light and Power Company installed four hydroelectric plants along the Housatonic River and created lakes, which many enjoyed for boating, swimming, and other water sports.

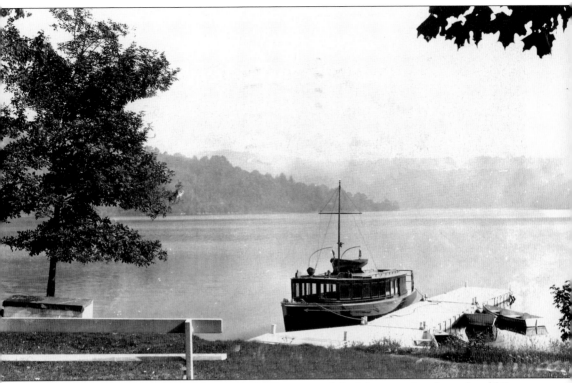

RIVERSIDE LANDING, LAKE ZOAR, C. 1929. The name of the lake was taken from the old Zoar Bridge. Real estate entrepreneur Soule-Roberts helped to build the area of Lakeside. Ed Scoville piloted the boat *Miss Riverside*, which provided tours around the area to encourage people to buy in the area. The sales office of Soule-Roberts Enterprises was originally located near the commuter lot off exit 14 on Route 84, next to the Lakeside sign. The office later moved to the Veteran of Foreign Wars Hall. The Lakeside Association took control of the area after Soule-Roberts and created a clubhouse.

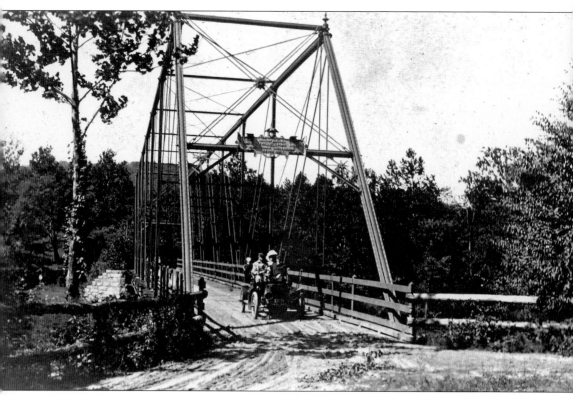

COUPLE CROSSING BRIDGE IN FANCY CAR. Before the Stevenson Dam and Lake Zoar, the toll bridges (Zoar and Bennett) were the principal Housatonic River crossings. Bennett's Bridge crossed at the west bank of the Pomperaug, and Zoar Bridge was on the Newtown side. The picturesque suspension bridge at Zoar was done away with when the Stevenson Dam was erected. During Colonial times, individual towns were responsible for bridges. Several highway surveyors were elected annually at a town meeting to take care of roads and bridges in a particular part of town. An annual highway tax was levied on households in direct proportion to how much land they owned. Residents who were short of money could pay part or all of their bill by working on the roads, lending their team of oxen to help, or providing the lumber for the roads. Most of the bridges were made from short spans of wood. Masonry bridges were cost prohibitive. Most bridge construction or maintenance was done in answer to petitions from the townfolk.

Seven

RUSSIAN VILLAGE

Count Ilya Tolstoy, a writer, initiated the idea of Russian Village. He escaped Russia in 1920 and came to New York. He visited Woodbury, where an English translator of his work lived. Very often he toured the Southbury area to see the rolling hills and rivers he loved. One day he wandered up a hill and found an area that reminded him of his homeland in Russia with the many birch, maple, oak, and pine trees. He said, "Am I dreaming a part of Russia?" E. G. Scoville owned the land. Only a few of the 26 original families still live here.

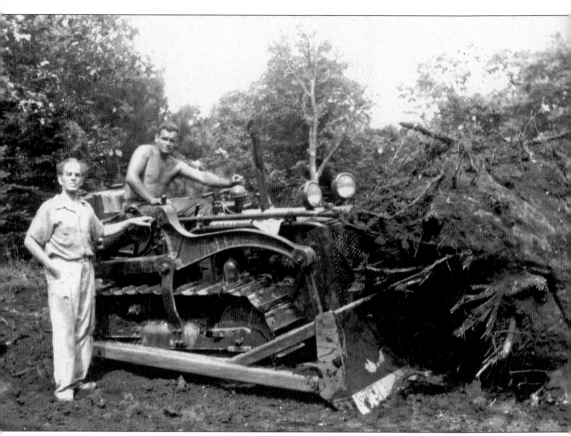

BUILDING RUSSIAN VILLAGE. Southbury contractor Melvin Wheeler is breaking ground for the beginning of Russian Village in the late 1920s. Ilya Tolstoy's dream of finding a home similar to his family's retreat in Yasna Polyana, a town about 130 miles from Moscow, had been realized. His friend Georgei Grebenstchikoff's recreation of the mythical village Churaevei in his three-volume novel about his native land had also come to fruition. Churaevka, a Russian village, became a reality in Southbury. In 1926, Grebenstchikoff felt the plan for Russian Village would be enriched with planning for a chapel, in tribute to the important part that religion had played in his life and Tolstoy's. The chapel was named for St. Sergius of Radonega, one of Russia's most honored saints. The cornerstone was laid as a memorial to the Cathedral of St. Savidur in Moscow, which had been demolished by the Soviets in the early 1920s. Nicholas Roerich designed the chapel, and the consecration ceremonies were conducted in 1932.